THE ARCHETYPAL
WORLD OF
HENRY MOORE

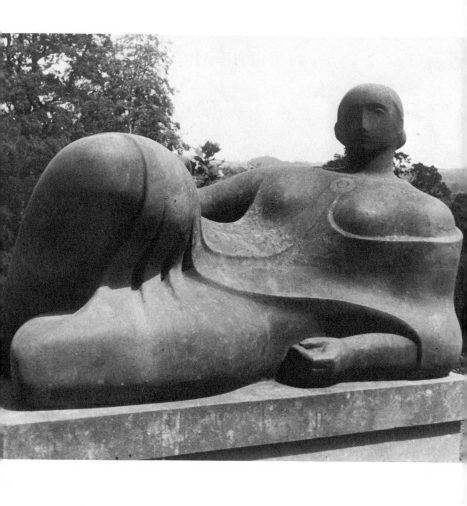

THE ARCHETYPAL WORLD

OF HENRY MOORE

ERICH NEUMANN

Translated from the
German by R. F. C. HULL

PRINCETON UNIVERSITY PRESS

BOLLINGEN SERIES LXVIII

Published by Princeton University Press, 41 William Street,
Princeton, New Jersey 08540

In the United Kingdom: Princeton University Press,
Guildford, Surrey

First Princeton Paperback printing, 1985

LCC 58-8988
ISBN 0-691-09702-X
ISBN 0-691-01865-0 (pbk.)

THIS IS THE SIXTY-EIGHTH IN A SERIES OF WORKS
SPONSORED BY AND PUBLISHED FOR
BOLLINGEN FOUNDATION

Translated from an unpublished manuscript:
Henry Moore und der Archetyp des Weiblichen

Clothbound editions of Princeton University Press books are printed on
acid-free paper, and binding materials are chosen for strength and dura-
bility. Paperbacks, while satisfactory for personal collections, are not
usually suitable for library rebinding.

Printed in the United States of America by Princeton University Press,
Princeton, New Jersey

CONTENTS

LIST OF ILLUSTRATIONS

The illustrations of works by Henry Moore are reproduced chiefly from photographs supplied through the courtesy of Percy Lund, Humphries & Company, Ltd., London; many of them were published in their own volumes on Moore (see p. 137). The artist himself has also supplied a number of photographs, both his own and by others, mostly unpublished. Other photographic credits (P) are recorded in the list below. Henry Moore's works are located in British collections, unless otherwise noted.

The page on which each illustration appears and other pages where the subject represented may be discussed are recorded at the end of each entry. Marginal numbers in text identify most references.

ACKNOWLEDGMENT

Grateful acknowledgment is made to Mr. Henry Moore and to Mr. Eric C. Gregory and Mr. A. de Fonblanque, of Percy Lund, Humphries & Company, for their kindness and help in connection with the illustrating of this book.

I

ONE constantly hears the objection that psychological art criticism, besides reducing the work of art to the personal psychology of the artist, is at most capable of grasping its material content, but is by nature unable to discuss the principle of form that constitutes the real essence of art and of artistic creation. For our attempt at a depth-psychological analysis of the art of Henry Moore, however, the interrelation of form and content is a problem of central importance; and it seems to us, therefore, that any approach which regards them as two separate "subjects" is untenable from the standpoint of depth psychology.

Analytical psychology sees the individual and his work not only as molded by his milieu and his childhood but also as part of a collective psychic situation. The transpersonal factors of the collective consciousness and of the collective unconscious are suprapersonal agencies that determine the life of every individual, and particularly of the creative individual, the artist.

What we call the *Zeitgeist* is the sum of all the psychic, spiritual, and social impressions that stamp an in-

dividual as belonging to classical antiquity, the Christian Middle Ages, the Romantic Age, or the Modern Age, and distinguish him from the men of all other ages. The cultural canon of highest values determining the culture of the particular age in which the creative individual lives is partly conscious and thus belongs to the collective consciousness of the time; it expresses itself in the religious, ethical, artistic, scientific, and social beliefs that are valid for that age. But these highest values are always based on unconscious premises, mostly of an archetypal nature, which are alive and operative in the unconscious of his contemporaries. Convictions and actions, whether they be those of religion, or of alleged knowledge, or of the collective *Weltanschauung,* are to a large extent "self-evident" for the person who has these convictions and performs the actions. That is to say, they are based on unconscious assumptions that determine his behavior, although he is completely ignorant of their existence. But the highest values in every culture are also symbolical values; and these, by their very nature, cannot be made wholly accessible to consciousness, let alone to rational thought. Thus in every culture and every age we find without exception that its cultural canon is determined by unconscious images, symbols, and archetypes. It is immaterial whether they express themselves as gods, as ideals and principles, as daemonic powers, or as the certainties of religious faith and superstitious belief.

Similarly, those contents which are lacking to the collective consciousness, and are often directly opposed to it and necessary for its compensation, are alive in the collective unconscious of the group. The dialectical law of Heraclitus, the law of enantiodromia, according to which any given position is always superseded by its negation, is grounded on the psychological fact that the one-sidedness of a conscious attitude which has been secured chiefly by repressing or suppressing all contents opposed to it leads to a piling up of such material in the unconscious. Since these contents are lacking to consciousness, its one-sidedness necessarily results in failure to adapt and other functional disturbances. In this sense the repressed and suppressed contents of the unconscious are not merely things that from the conscious standpoint are "forbidden" and tabooed; they are also compensatory with respect to the wholeness and completeness of the personality and of culture.

Now it is the function of the creative individual not only to represent the highest transpersonal values of his culture, thereby becoming the honored spokesman of his age, but also to give shape to the compensatory values and contents of which it is unconscious.[1] By representing the values that are compensatory but in opposition to the cultural canon of his time, he naturally becomes an outsider, who on that account has often enough to suffer the fate of a scapegoat.[2] For the historian, however, grasping the whole process in retrospect,

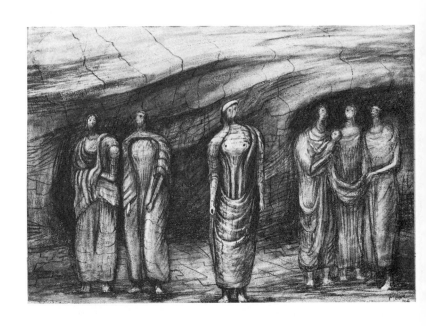

1. STANDING FIGURES WITH ROCK
BACKGROUND. *Chalk, pen, and
water color. 1946. 15 x 22"*

the revolutionary and heretic, whether it be a Hebrew
prophet or Socrates, Joan of Arc or Galileo, is as much a
part of his culture as the representatives of the cultural
canon who condemned him.

When we try to grasp the role of the creative individ-
ual, as an artist, in relation to the cultural canon, we
shall see that, apart from differences in the individuali-
ties of artists, a change in the *Zeitgeist* manifests itself
most of all in the changing *content* of art. One has only
to think, for instance, of the sacral content of medieval
art and contrast it with the worldly tone of the art of

the last hundred and fifty years, when landscape, individuals, and things came so powerfully to the fore. But a change in the *Zeitgeist* can also express itself in a changed *conception of form*, though the content remains the same, as in the depiction of religious subjects during the Middle Ages and the Renaissance. Deeper psychological analysis will show, however, that a new principle of form is in reality always an expression of a new content. The new content may develop at first under the cloak of the old cultural canon and make use of it, but gradually breaks it down by force of the new formal principle and finally becomes tangible and conscious as a new content. *e.g., 1*

Thus a new experience of reality progressively transformed the old religious contents at the beginning of the Renaissance. Artistic creation departed more and more from the medieval world of sacral, suprapersonal forms and discovered, under the symbol of earthly reality that governed the rise of the new cultural canon,[3] the individual uniqueness not only of things and landscape but of the national differences now becoming visible and of personality itself. Now for the first time there was a true Flemish and Italian art, a true French and German art, and only now does the portrait appear as something personal and unique, which is not—as in the Middle Ages—stamped only by a collective human situation, e.g., original sin, or by a collective attitude, e.g., prayer.

The archetypal content and the form in which it manifests itself belong essentially together. The heaven-aspiring quality of Gothic art is, as a formal element, determined by the archetype of an all-dominating heaven, just as the closed, self-contained forms of Egyptian sculpture are a reflection of the closed archetypal world picture of the ancient Egyptians.[4]

An archetype, a primordial image, is always polyvalent; it can express itself and be looked at in any number of ways. It possesses a great diversity of aspects—one has only to think of the infinite variety of forms in which the image of the Father God is reflected in the religions of mankind. Apart from that, every archetype is "two-faced," ambivalent, and has a "good" and a "bad" side according to the attitude the conscious mind adopts toward it. So if we speak of a correlation of artistic form and archetypal content, such a correlation always presents a complicated psychological problem. The aspect of the archetype—whether God or devil, demon or angel—can only be viewed in relation to the *Zeitgeist*, to the attitude of the cultural canon toward it, and of the creative individual toward the cultural canon.

So although no archetype has a definite form that belongs to it for all time, and in which it manifests itself and has its being, a correspondence between the archetypal form and its content can nevertheless be demonstrated in the art of civilized artists, as well as in the art

of primitives, lunatics, children, dilettante adults, and in the drawings and paintings produced under analysis. Without some such correlation it would not be possible either to understand these products or to interpret them psychologically. That is to say, an "earthy" subject will not appear in "airy" forms and colors, nor will a "fiery" subject appear in "watery" ones. It is no accident that in this example we have employed symbols whose qualitative meaning is self-evident to everybody. A "dead" sun in a painting by a lunatic can be experienced as directly as can the emotional chaos of churned-up earth in a picture by van Gogh; our experience of the picture stamps the artistic impression it makes on us, the mood it creates, and the associations that attach themselves to this mood. But an interpretation of these symbols, the conveying of their meaning to consciousness, is possible only with the help of the comparative method, which views the symbols of all cultures and epochs within their cultural context and as parts of a transpersonal archetypal structure.

In pursuing the archetypal element in art, we at once come upon a very characteristic difference in the idiosyncrasies of artists. That is, one artist will circle round one and the same center in his work and thus, despite possible variations of expression, remains "uniform," as for instance a Madonna painter, a landscape painter, or Henry Moore. Another type of artist, such as Picasso, will be gripped in the course of his development by

ever new contents and compelled to ever new forms of expression.

Yet, as we shall try to show in the case of Henry Moore, in this fascination by one archetype and in the artist's concentration upon it, it is quite possible for the whole of life to be grasped in its transformations; for every archetype is an aspect of the whole world and not just a fragment of it. On the other hand—and this is not to be taken as referring to the peculiar idiosyncrasy of Picasso—it is equally possible for an artist's work to touch on a wealth of archetypal contents without his psyche ever being profoundly and uniformly gripped by an archetype. We then have, as with Böcklin or Klinger, an art that is full of archetypal contents but whose formal quality fails to do justice to them.

The incongruity between content and form thus becomes an essential criterion for any depth-psychological approach to art, since the intensity with which the artist is gripped must also express itself in the intensity and quality of the forms he creates. An archetypally adequate Madonna differs from a picture-postcard Madonna, not because of any difference of content, but only because of the form, which looks "cheap" in the hands of an artist not gripped by the archetype. That is to say, the quality of the artist and the depth to which he is gripped have nothing to do with the content of his picture. Consider, for example, the pre-Raphaelites in contrast to Rembrandt. With the pre-Raphaelites the

"large" content shows itself to be essential only to the large scale of the pictures, whereas in quality of form and coloring the figures are on the smallest scale. With Rembrandt, on the other hand, the object represented is quite unimportant, but even in the smallest sketch— of a beggar, for instance—he formulates the problems of the whole world and its need of redemption, and at the same time bathes it in a mysterious redeeming light that plays over all.

Although the adequacy of form to content is a problem that can be successfully solved regardless of technical perfection—as is proved by the drawings of children and, for instance, van Gogh—in the highest form of art, profundity of vision and absolute control of technique go hand in hand. But the adequacy of form to content does not depend on the conscious discernment and comprehension of the artist, who need not "know" anything about the content to which his work is dedicated. The realization of the archetype that has such a transformative effect on his personality, for good or ill, is not bound up with any conscious recognition of its contents. This means, conversely, that the conscious motivation of the artist need not be identical with the real unconscious motive or content that actuates him; the two may correspond with one another, but they may also be divergent. For instance, the hellish torments depicted in the work of Hieronymus Bosch are quite consistent with a pious mentality that finds itself

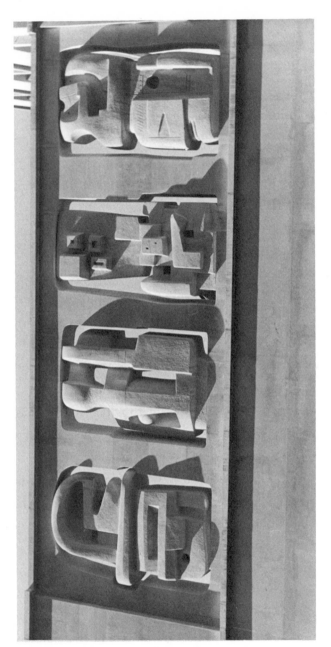

2. "TIME-LIFE" SCREEN IN SITU. *Portland stone. 1952/53. H. 10'*

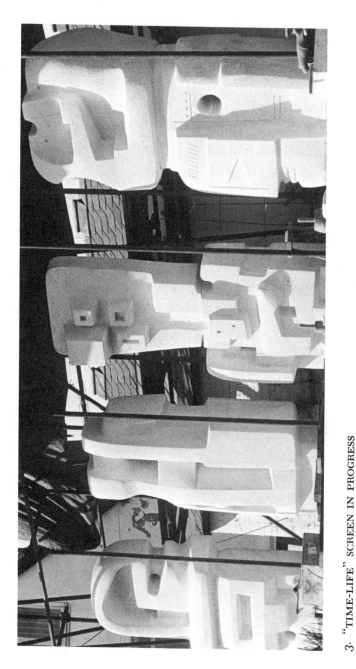

3. "TIME-LIFE" SCREEN IN PROGRESS

in full agreement with the cultural canon of the Middle Ages. Today, however, no depth psychologist, or any psychologist at all, could fail to recognize that this choice of motif, like the tortures of the Inquisition of which it is a reflection, springs from an unconscious sadism that asserts itself regardless of the religious or antireligious attitude of the conscious mind.

e.g., 2, 3

In the same way we find in the development of modern art a distinct tendency toward abstraction, for which there are various conscious motivations. But a large part of this will for abstraction is unconscious, and subserves the tendency to seek out and give shape to the primordial image as opposed to the delusory phenomenal image. It arises from a time trend in the collective unconscious of which only a few individual artists are aware.

II

WHEN we approach the work of Henry Moore from the points of view we have suggested, and try to understand the connection between artistic creation and archetypal reality, we shall see at once that Moore is one of those creative individuals whose work revolves round the centrality of a definite content. We shall also have to understand the significance of the fact that, although we are still living in a patriarchal culture largely governed by the masculine spirit, the "Primordial Feminine" stands at the center of his work with such exclusive emphasis.

"There are two particular motives or subjects which I have constantly used in my sculpture in the last twenty years: they are the 'Reclining Figure' idea and the 'Mother and Child' idea. (Perhaps of the two the 'Mother and Child' idea has been the more fundamental obsession.)" [1] In this sentence Moore says something decisive about himself and his work. Not only does he indicate its central content, but, in speaking of these two motifs as "ideas" and of himself as a man with an "obsession," he illuminates the whole inner landscape of his art as with a flash of lightning. One would go

very much astray, however, if one supposed from this statement that the peculiarity of Moore's work consisted in the visionary shaping of an inner archetypal image, in the manner, say, of the Surrealists, who bring forth inner images for our contemplation. Although he is, in the true sense, the "seer" of an inner archetypal figure that we could call, for short, the "Primordial Feminine" or the "Great Mother," it is clear, as perhaps nowhere else in the history of art, that for Moore this archetypal image or "idea" is neither inside nor outside, but has its true seat on a plane beyond both.

If the essence of Moore's work lies in its concentration on the archetype of the feminine, then its radical advance from the naturalistic and representational to the "abstract"—though this, as we shall see, would be something of a misnomer in his case—is not to be understood as a formal process having its analogy in the trend of modern art as a whole. The unique feature in the development of Moore's art is that this apparently formal process goes hand in hand with an ever-changing revelation of its archetypal content, in which this content achieves ever greater authenticity and clarity. That this unfolding of the archetypal core of the feminine, together with its spiritual symbolism, should be able to depict itself in the concrete reality of the sculptor's material, and never abandon this concreteness despite all its so-called "abstract" and "conceptual" qualities, is in our view one of the most astonishing paradoxes of Moore's art.

4. MOTHER AND CHILD
Portland stone. 1922. H. 11"

Two essential features characterize Moore's work. The first is his "obsession" with the feminine—in Moore's extensive repertoire there is scarcely one sculpture whose subject is not feminine—and the second is the development of the formal principle from a more or less naturalistic representation of objects to a semi-abstract or at any rate non-naturalistic type of art. The two trends appear to be independent of one another, but it is our thesis that the change of form is in reality an inner unfolding of the archetype and idea of the feminine, of what the "'feminine as such" means. So far as can be gathered from his utterances on the art of sculpture, however, this spontaneous unfolding of the "real" theme of his work seems to have reached Moore's consciousness only sporadically. He himself, so far as he theorizes at all, seeks a new conception of sculpture that in many respects seems to run parallel with the general trend of modern art, but he is not conscious of the extent to which the specific content of his work, the feminine as such, determines his conception of sculpture.

The main difficulty before us is that we cannot begin our exposition by defining what the "archetype of the feminine" is, in order to exemplify its meaning in Moore's work. No such starting point is possible, because the archetypal can only be laid hold of in its transpersonal manifestations, in myths, fairy tales, dreams, etc., but can never be grasped with the help of

6. MOTHER AND CHILD
Hornton stone. 1924/25. H. 22½"

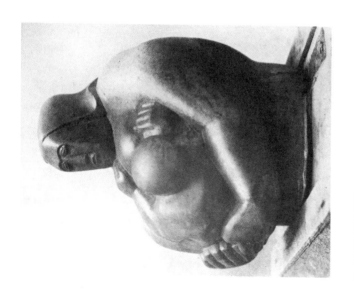

5. MATERNITY
Hopton-wood stone. 1924. H. 9"

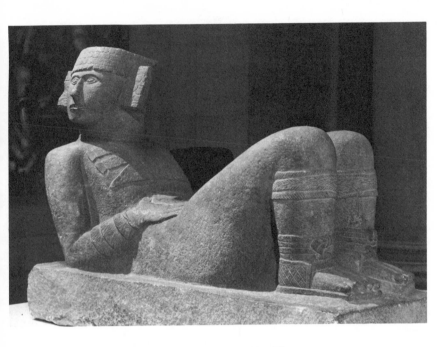

7. CHAC MOOL, THE RAIN SPIRIT
*Mayan (New Empire), from Chichén
Itzá. 948–1697. Limestone. L. 58½″*

purely abstract conceptions. For this reason we must
try to trace the development of Moore's conscious and
unconscious intentions and at the same time discover
the meaning of the archetype of the feminine without
separating the two interrelated principles of form and
content.

As we follow Moore's development we shall see that
it is always the two great themes of mother and child
and the reclining figure round which his art unfolds.
All other objects are only peripheral; they prepare, il-

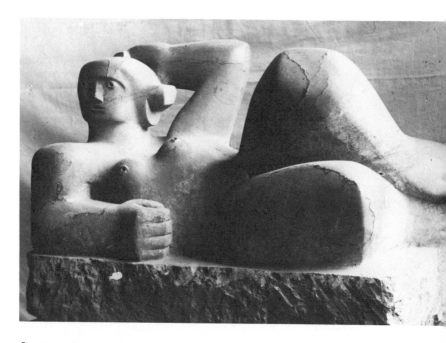

8. RECLINING FIGURE
Brown Hornton stone. 1929. L. 33"

lustrate, and elucidate what is going on in this central
zone of the feminine.

Even his earliest sculptures, groups from the years
1922–25, are configurations of the mother-child prob- 4,5,6
lem. In them the so-called naturalistic elements still
predominate, but already in their form and content the
ground motif of Moore's art is struck: the apprehension
of the feminine archetype. Art criticism today generally
sees in the sculptures of this period—and rightly so—
the influence of primitive art, whether Sumerian, pre-
Columbian, or African. If we compare the "reclining

7 figure" from Mexico, the inspiring "prototype" of all
 similar figures in Moore, with the large *Reclining Fig-*
8 *ure* from the year 1929, and take this group of sculp-
 tures as the first unit in Moore's development, then the
 "primitive influence" seems not only self-evident but
 also sufficient as an "explanation." [2]

 For a depth-psychological analysis, however, the real
 problem only begins here. Moore himself says of Mexi-
 can art: "Mexican sculpture, as soon as I found it,
 seemed to me true and right, perhaps because I at once
 hit on similarities in it with some eleventh-century
 carvings I had seen as a boy on Yorkshire churches. Its
 'stoniness,' by which I mean its truth to material, its
 tremendous power without loss of sensitiveness, its as-
 tonishing variety and fertility of form-invention and
 its approach to a full three-dimensional conception of
 form, makes it unsurpassed in my opinion by any other
 period of stone sculpture." [3]

 We shall be concerned with two aspects of this quo-
 tation. The first is what Moore, in keeping with the art
 theories of our time, says about form; the second is that
 curious "personal" association of Mexican art with
 Moore's childhood memories—an apparently psycho-
 analytical train of thought. With regard to the impor-
 tance of the formal principle, it should be noted first of
 all that the Mexican prototype of the reclining figure
 represents a masculine deity, whereas Moore's figures
 are exclusively of the feminine goddess who stands

namelessly at the center of his art. So already in this first group the trend is from the personal to the trans-personal, from a merely personalistic portrayal to the creation of a suprapersonal and eternal content or relationship.

Whether the child seems to burst forth underneath, 4 as though being born from the stony immobility of the mother, or, drinking at her breast, forms a unity with 5 this huge mountain, or rises above her triumphantly, 6 with almost somber intensity, always the mother-child motif is conceived as something archetypal, perennially human, the ground theme of life. And it suddenly becomes clear that all formal considerations are not peripheral but completely fused with Moore's innermost intention, of which perhaps even he himself is unconscious. He seeks to create an archetypal and essentially sacral art in a secularized age whose canon of highest values contains no deity, and the true purpose of his art is the incarnation of this deity in the world of today.

This principle of incarnation lies at the root of all Moore's views on form, which he has expressed in his remarks on his work as a sculptor. Implicit in the mother-child motif is the whole of man's relation to the world, to nature, and to life itself. In the course of Moore's development the female reclining figure becomes more and more clearly the archetype of the earth goddess, nature goddess, and life goddess. This is not to

say that he "knows" about these things, or that he sets out to create "symbolic" figures as ordinarily understood. Only when the unwearying revolution about the feminine center becomes transparently clear in his work as a whole, and one sees how this center continually unfolds in the stadial development of his art, can one understand the essentially symbolic and archetypal nature of the deity to whose incarnation Moore's work is dedicated—one could even say "consecrated."

8 Whereas the *Reclining Figure* from the year 1929 might still represent an earth goddess in the sense that 7 the Mexican figure represented a god, with the figure 9 from the year 1930 a new principle of representation begins to operate: the transformation of the earth goddess into the earth itself. It is justly remarked of this figure that "it draws an analogy between a reclining woman and a range of mountains which announces the treatment of the female body as a landscape that characterizes most of Moore's later reclining figures." [4] If—to anticipate—we compare it with the *Reclining Figure* from 10 the year 1933, this transformation into the transpersonal earth can be seen very clearly. These sculptures do not "express" or "describe" anything, they are not allegorical or symbolical representations of the earth after the manner, say, of a Roman Abundantia or a figure by Maillol; they *are* earth, are a direct incarnation of what the earth archetype is.

This "being the thing itself," this "quiddity," is ex-

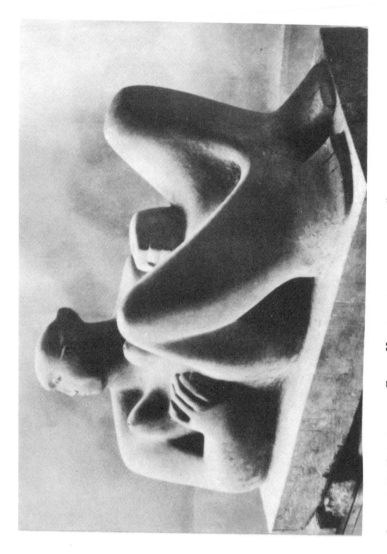

9. RECLINING WOMAN. *Green Hornton stone. 1930. L. 37″*

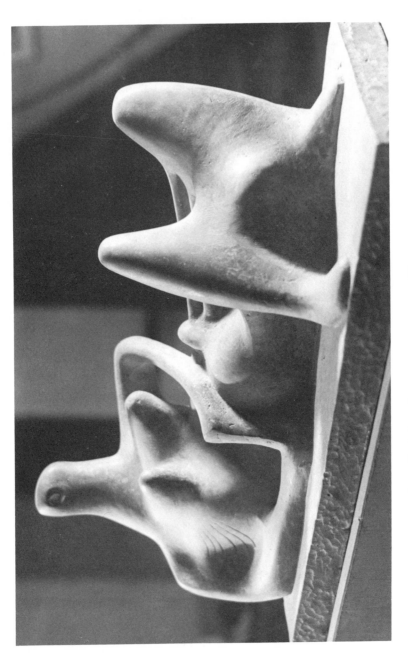

10. RECLINING FIGURE. Carved reinforced concrete. 1933. L. 30½"

pressed in Moore's broad specification of what sculpture ought to be: "The sculpture which moves me most is full-blooded and self-supporting, fully in the round; . . . it is static and it is strong and vital, giving out something of the energy and power of great mountains. It has a life of its own, independent of the object it represents." [5]

In the creative act the artist identifies himself with the thing created, as though giving out a part of himself, like a mother with her child. "He gets the solid shape, as it were, inside his head,[6] he thinks of it, whatever its size, as if he were holding it completely enclosed in the hollow of his hand. He mentally visualizes a complex form from all round itself; he knows while he looks at one side what the other side is like; he identifies himself with its center of gravity, its mass, its weight; he realizes its volume as the space that the shape displaces in the air." [7] The "embracing" quality of the mental creative process is conceived here, characteristically, as an act of envelopment, and "head," "hand," "space" appear as maternal symbols by which the created thing is enclosed. At the same time, the created thing is left free in its multidimensional independence and "self-centeredness."

This description of the creative act is informed throughout by the "Maternal Feminine" principle, and is an extremely concrete expression of what we have termed elsewhere the "matriarchal consciousness." [8]

The essence of this creative process is that it springs from, and mostly takes place in, the unconscious. It is a process of pregnancy and inner maturation in which the ego consciousness participates only in the auxiliary role of a midwife. The essential thing here is the form pre-existing in the material itself; by obeying the material, the artist perceives this form and brings it to birth. When Moore says, "The sculpture . . . is full-blooded and self-supporting, fully in the round. . . . It has a life of its own, independent of the object it represents," he means that the reality of the sculptural object subsists "in itself" and is only discovered and externalized by the artist. Nevertheless, the process that makes this kind of creation possible is described by Moore as an essentially "enveloping" one. The exact opposite of this is the more "active" type of sculpture, which hacks out of the "passive" and formless stone something that corresponds to the artist's interior image. In this case it is simply a question of transferring or "projecting" the inside thing to the outside by a deliberate act of the will. The relation of creative mind to created matter is then more like the conscious confrontation of subject and object; it is less a creative than a procreative process, whose most modern form is the making of a machine, which—*contra naturam* and *extra naturam*—is nothing but a product of man's consciousness.

The relation between the creative process and the created form is completely different in Moore. From

11. MOTHER AND CHILD
Verde di Prato. 1929. H. 4¾″

12. MOTHER AND CHILD
*Effigy vessel. Peruvian (Chimu
culture). Pre-Columbian*

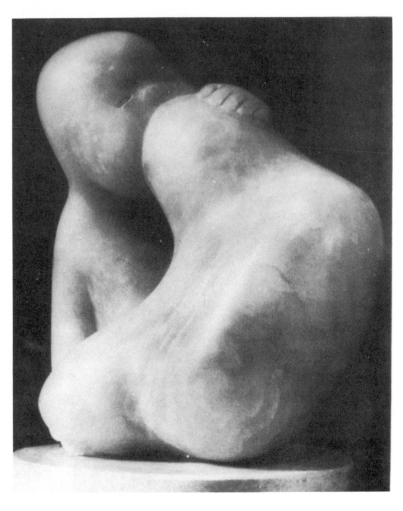

13. SUCKLING CHILD. *Alabaster. 1930.* H. 7¾″

the perpetual relationship of identity between the thing
to be formed and its former a work is born, and in this
birth no part does violence to any other; for the form-
less fertilizes the former just as much as the former de-
livers and gives birth to the form. In this process Nature

herself becomes creative in the creative individual, expressing herself in him and through him in her role of natural sculptor of created things.

This maternal Nature who creates the world of forms is the true object of Moore's work. The basic phenomenon that all life is dependent on the Primordial Feminine, the giver and nourisher, is to be seen most clearly in the eternal dependence of the child on the mother. And it is precisely because the creative individual, being dependent on the nourishing power of the maternal creative principle, always experiences himself as the "child" that the mother-child relationship occupies such a central place in Moore's work.

For this maternal Nature the child is something enclosed and attached, always overshadowed by the great curve of the mother. And whether the child lies snugly ensconced in the mother's breast, as in the figure from *11* the year 1929, or is inserted into her like an embryo, as in the figure from the year before,[9] the supremacy of the mother is felt with the same intensity as in primitive sculpture, for instance, the sculptured jars of Peru. *12*

In developing the theme of the Feminine as the Great Opposite, whose natural corollary is the childishly small, Moore advanced beyond the realm of envelopment and containment, protection and shelter, to one in which the Feminine appears as something rounded and curved like a fruit, whose epitome is the woman's breasts. This motif can be seen most clearly in the *Suck-* *13*

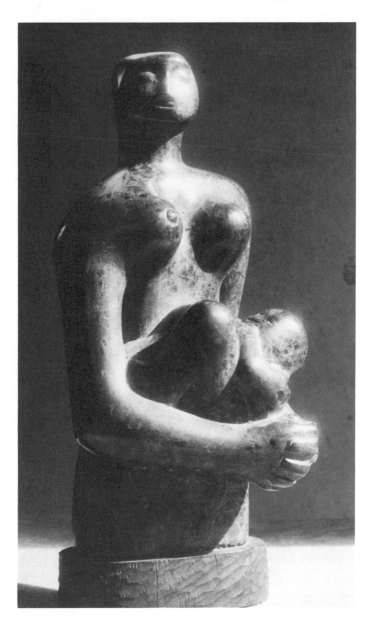

14. MOTHER AND CHILD *Verde di Prato. 1931.* H. *8″*

ling Child from the year 1930, where the woman is re-
duced to nothing more than the globed fruits of her
breasts. In the *Mother and Child* from the year 1931 *14*
the curve becomes the formal principle itself, repre-
sented not only by the mother's breasts but by her
head, the child's knees, and the globe of its head. The
woman and her child are shown—still in concretely
representational style—as a living cluster of fruit, crea-
tive Nature made manifest as the Maternal Feminine.
Moore is attracted to these living forms because, as he
rightly says, "Asymmetry is connected also with the de-
sire for the organic (which I have) rather than the ge-
ometric." [10] But his understanding of himself goes even
deeper, and in his "Notes on Sculpture" he formulates
the essential elements of the feminine archetype's form
and content in exactly the way that depth psychology
and especially analytical psychology conceive them:
"I am very much aware that associational, psychologi-
cal factors play a large part in sculpture. The meaning
and significance of form itself probably depends on the
countless associations of man's history. For example,
rounded forms convey an idea of fruitfulness, maturity,
probably because the earth, women's breasts, and most
fruits are rounded, and these shapes are important be-
cause they have this background in our habits of per-
ception. I think the humanist organic element will
always be for me of fundamental importance in
sculpture, giving sculpture its vitality." [11]

III

WHEN one follows the maturation and development of sculptural form in Moore from its naturalistic beginnings to the later fruitlike mother-and-child groups, it seems incomprehensible at first how Moore could ever have come under the influence of Picasso and of abstractionist sculpture like that of Brancusi, Archipenko, and Arp. Does not this trend stand in direct contradiction to the self-incarnation of the feminine archetype?

Let us consider the three reclining figures from the years 1934 and 1935, which are characteristic of this "abstract" period. Only in the *Four-Piece Composition* does the analytical element in the abstraction predominate to such an extent that the whole figure falls apart. In this stone anatomy the legs have made themselves independent as isolated formal elements, head and thorax form a peculiar bipolar structure, and the rest of the figure is reduced to an egg, the germinal form of all life. The separate parts are the expression of an abstract principle that not only denies the seeming reality of the empirical world, not only reduces all accidentals to the barest essentials, but breaks down the "anatomy of reality" into fragments, so that all that is left is the posi-

15, 16, 17

15

tion of the parts and the memory of the complete body image. The denaturing and dehumanizing of sculpture are carried to extremes in this work; never again do we meet with a similar disintegration of form. The inner relations, i.e., those obtaining between the parts of the figure but not represented in the material itself, are not sufficiently strong to prevent the sculpture from collapsing. Characteristically, the mother-and-child motif is very much in abeyance in this abstract period, perhaps because the emotional quality naturally associated with it resists abstraction.

Since the principle of simplification plays such an important part in Moore's work, we must try to distinguish this concept from the more general concept of abstraction. The abstraction apparent in the *Four-Piece* 15 *Composition* is not a simplification of form, but rather a deformation, willed and in a sense deliberately thought out by the abstracting consciousness, and so far removed from everything plastic that the formal relations on which the aspect of wholeness depends almost completely disappear. This kind of abstraction, as with Arp in sculpture and Mondrian in painting, leads to pure formalism and is alien to Moore's innermost purpose, indeed directly opposed to it. Because his object is the nature of the feminine and the mother-child relationship, his simplification of form never passes over into the purely geometric and schematic. Even in the "abstract" *Reclining Figure* assigned to the years 1934/ 16

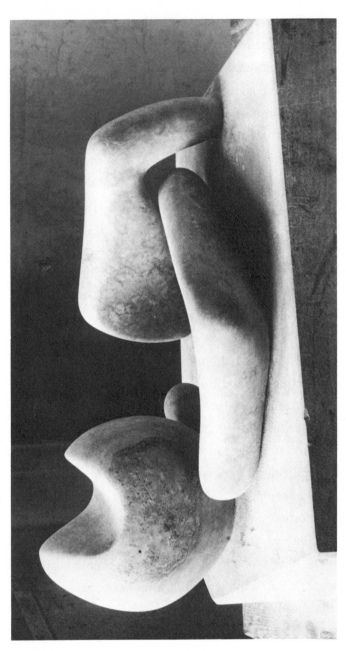

15. FOUR-PIECE COMPOSITION: RECLINING FIGURE. *Cumberland alabaster. 1934. L. 20"*

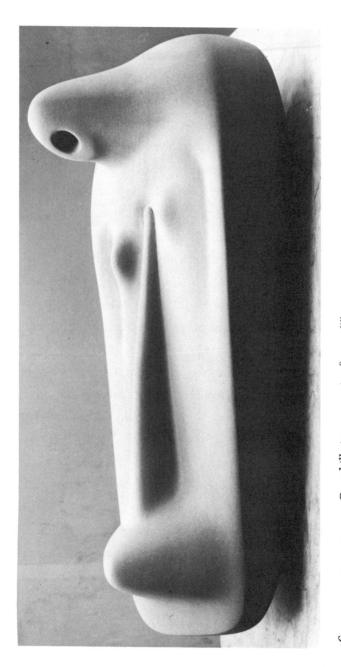

16. RECLINING FIGURE. *Corsehill stone. 1934/35 ? L. 24½″*

35, which is reduced almost entirely to simplified formal elements, the symbolic accent is so strangely clear that, in some way the intellect can hardly understand, the character of the figure is still preserved. It is practically all pure form, yet the stone protuberance with the hole in it is unmistakably a head, the little bump lower down is enough to suggest one of the breasts and consequently the torso as well, while the curious raised ridge running down the center and ending in a mound of earth that forms the counterpart to the head, although quite inexplicable anatomically, constitutes, together with the other elements, a simplified body form which —and this is its essential difference from the anatomy of the *Four-Piece Composition*—is immediately effective as a whole figure.

In contrast to these two, the third *Reclining Figure* is much closer to nature. Here Moore has put into practice the kind of abstraction we would call "simplification," which, although departing from naturalistic detail, nevertheless grasps the plastic character of the object in its essence. Here "essence" does not imply any abstract, intellectual schematization, but means rather that both the essence of the recumbent body and the essence of the stone have become visible and tangible reality. For all its simplification this figure remains essentially feminine. (In the *Four-Piece Composition* all that remained was an anonymous thing that bore hardly any resemblance to a body, like something from the

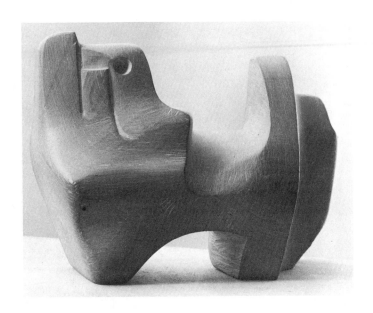

17. RECLINING FIGURE
African wonderstone. 1934. L. *6″*

dissecting room.) The stony nature of the stone is not
only preserved but emphasized in the weight of the fig-
ure, yet in its simplification the figure makes such a
powerful impression of wholeness that it integrates all
the barely suggested details. This simplifying technique
is the kind of abstraction that characterizes Moore's art
from now on. Transcending all cubist and constructivist
tendencies, the archetype of the feminine again asserts
itself, but more powerfully than before. The principle of
simplification places itself more and more clearly at the
service of a transpersonal, creative will that abjures all
naturalistic details and everything personal and acci-

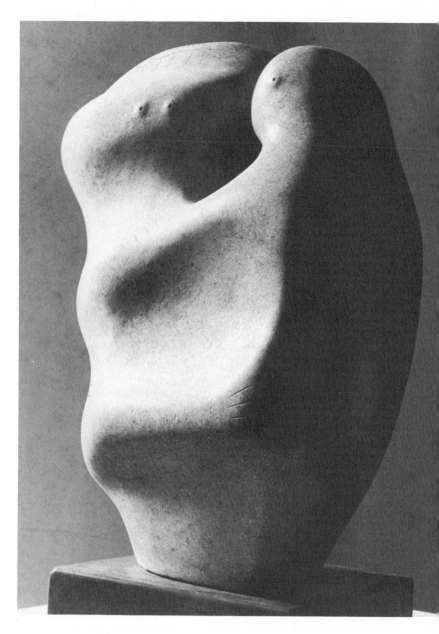

18. MOTHER AND CHILD. *Ancaster stone. 1936.* H. 20"

dental. The "abstract" and transpersonal in Moore is the authentic and deepest expression of this numinous power which, as often among primitive peoples, manifests itself not in representational but in an abstract, spiritual art. "My sculpture," he says, "is becoming less representational, less an outward visual copy, and so what some people would call abstract; but only because I believe that in this way I can present the human psychological content of my work with the greatest directness and intensity." [1]

Consider the *Mother and Child* figures from the year 1936; all materialistic detail has been melted away from them, and only the "pure form" remains. It is hardly possible to represent the feeling of unity, intimacy, and partial identity of mother and child more powerfully and simply than in the double block, where the horizontals formed by their mutual embrace determine, in their roundness and firmness, the whole structure. We find something analogous only in the double images from Cyprus, which also may represent the goddess and child, and suggest the same intimate relationship by the unity of material (there of the block, here of the clay surface) as well as by the double cross-connection (vestiges of arms, ornamental bracelets).

In the image of the goddess with the child—I say "goddess" because everyone will be struck by the suprapersonal quality of this figure, monumentally set in the landscape like one of those statues on Easter Island

18, 20

18

19

20

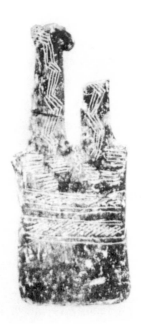
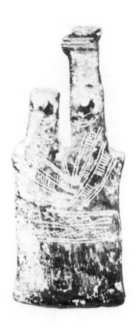

19. DOUBLE PLANK-SHAPED
FIGURE. *Clay. Cypriote, c. 2500–*
2000 B.C. H. 10⅜"

—the child has almost the effect of an ornament. It is stone of her stone, and yet how firm and secure it stands on the unshakable plinth of the arm! How strangely human is the oneness of these two beings, how eternal and unchanging their kinship, and how natural! Can one apply the epithet "abstract" to a work of art that rises up like a piece of nature in its natural setting, and seems to belong to it like a rock or a tree? Moore says: "Sculpture is an art of the open air. Daylight, sunlight is necessary to it, and for me its best setting and complement is nature. I would rather have a piece of my sculpture put in a landscape, almost any

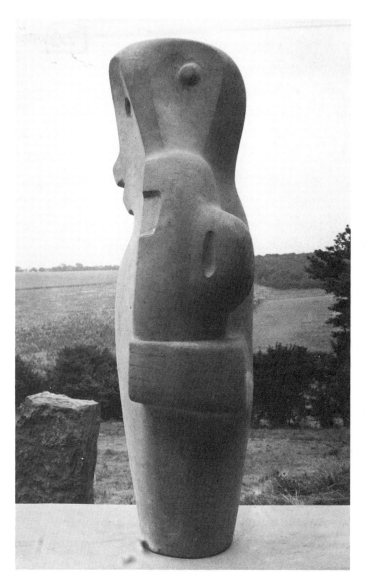

20. MOTHER AND CHILD
 Green Hornton stone. 1936.
 H. 45″

landscape, than in, or on, the most beautiful building I know." [2] Of this sculpture, which has practically turned into nature, we can say what Moore himself says about nature: "A large piece of stone or wood placed almost anywhere at random in a field, orchard, or garden, immediately looks right and inspiring." [3] These works of Moore's are art and nature, abstract and yet close to reality in a sense that gives a new significance to the word "primitive," if one understands this word in the way Moore himself understands it, as connoting an intense feeling of oneness with the forces of nature.

Only when we understand Moore's dictum "All art has its roots in the primitive" [4] correctly can we understand the essence of his artistic purpose. He says of primitive art: "It is something made by people with a direct and immediate response to life" and "a channel for expressing powerful beliefs, hopes, and fears." [5] His own sculptures conform in large measure to this definition. This explains his efforts to reduce sculpture to the essential, which can only be termed "abstract" if one takes this term as not implying anything conceptual or intellectual. Some of the work produced in this period is abstract in the sense that a work of Giotto's is more "abstract" than, say, a Botticelli. It is reduced to its primary form, and is archaic in the sense that the archetypal may be found to underlie, like a simpler and more authentic substrate, as their "arche" or origin, all the phenomenal forms in which it manifests itself.

A basic feature of all modern art is its striving to get back to the archaic again, to the original source beyond our differentiated modern consciousness. Moore's return to the archaic must be understood at the same time as a return to the essence of sculpture itself, where the earth becomes creative in the materials proper to it—stone, wood, and metal.

For Moore this proximity of sculpture to the plastic creativity of nature gives his art a kind of numinosity and also relates it to the art of primitives. For him the hallmark of all life, the capacity of the living thing to have its center of gravity in itself, to be rounded on all sides and charged with vitality, is found not only in the organic realm of animals and human beings but appears just as much, or even more forcefully, in the numinous "aliveness" of earth, rock, wood, and bone. If at a certain period of his life and work he has been fascinated by the intrinsic vitality of pebbles, boulders, flints, bones, bits of wood, etc., it is not enough to speak of the influence "of natural objects on Moore's language." [6] When A. D. B. Sylvester tells us that "the artist has used his studies of pebbles to invest his sculptures with the illusion of being boulders shaped by wind and sea," [7] we would remark that the word "illusion" is just as misleading as is the word "used." This is precisely what Moore does *not* do. It is not a question of his making conscious sophisticated use of primitivisms, a procedure altogether typical of an artist like Picasso,

but rather an attempt—and a successful one—to get at the essential nature of the stone or the wood and to shape it, as it were, "from inside," from its own center, with all the piety with which stones are worshiped as sacral objects in primitive cultures. Later we shall see in detail how this approach of Moore's has led to the creation of absolutely novel forms. The mason's approach "from the outside," the whole concept of processing, using, applying, and indeed shaping matter, whether wood or stone, for an alien purpose, and thus degrading it to so much raw material, is here opposed by the altogether different attitude of the artist. For him its origination from the creative "Mater" is still so alive in "living" matter that one could almost say he serves only in the capacity of a midwife, helping her to bring forth into reality the intention slumbering within it. Naturally this description is exaggerated, but it points the contrast between Moore's return to the archaic and other forms of primitivism.

The approximation of Moore's art to the archetypal and the numinous gives it a form that in its quality, not in its stage of development, equals that of primitive art. When Moore says of African art that "for the Negro, as for other primitive peoples, sex and religion are the two main interacting springs of life," [8] one must take sex here in the very broad sense lent to it by psychoanalysis, remembering at the same time that the feminine principle holds the central place in Moore's art.

Since this principle, which for the male always remains coupled with sex, appears again and again in Moore's work in increasingly archetypal and transpersonal form, what he has distinguished as the essential feature of primitive art is equally true of his own art, namely, that in it too "sex and religion are the two main interacting springs of life." Similarly, what he says about Negro carving is true of his own work: "Much Negro carving . . . has pathos, a static patience and resignation to unknown mysterious powers; it is religious and, in movement, upward and vertical like the tree it was made from, but in its heavy bent legs is rooted in the earth." [9]

The fact that in its quality, but not in its stage of development, Moore's art resembles the art of primitives means that consciousness, for him, plays a decisive role. This is confirmed by his remarks on art in general and on his own art. Even in the period when, particularly in his drawings, he exposed himself, like the Surrealists, to the automatism of the unconscious, he never underestimated the formative and guiding role of consciousness. For such an attitude, which alone is adequate to the consciousness of modern man, the inner demand to keep artistic creation alive and open to the archetypal depths is particularly difficult. It is fascinating to see how the great artists of modern times have, each in his own way, tackled this central problem of preserving, side by side, the genuineness of the archetypal world and the acuity of a discriminating modern conscious-

21. MOTHER AND CHILD
Elmwood. 1938. H. *36″*

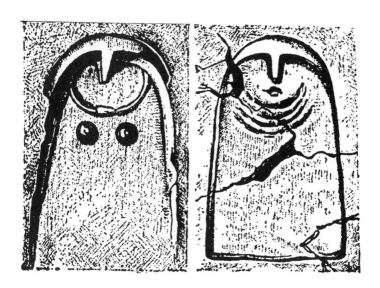

22. THE GREAT MOTHER
 Reliefs in limestone grottoes,
 France. Neolithic

ness. What in Picasso led to a continual dialectic be-
tween the thing apprehended and the manner of appre-
hending it, and in Klee to a specific but consistent
technique, where every line and every image reveal a
new aspect of this spectral world, compelled Moore to
create the same thing over and over again in a sort
of fascinated monomania—the primordial image of
Woman, Woman in her relation to and identity with
the great Earth Mother, as the reclining figure, or
Woman as the mother with the child. Only when we
grasp Moore's connection with the archaic can we un-
derstand his "abstract" and at the same time "primi-
tive" sculptures correctly.

Let us turn now to the strange wood carving of mother and child from the year 1938. Here again the child is only hinted at, but already it stands, already it has a certain independence. And yet it remains overhung by the maternal arch, which in its simplification is reminiscent of the neolithic statues of the Great Mother in France.

Like every primordial image, the archetype of the Great Mother round which Moore's work revolves has not only been an object for religious veneration all over the world since the remotest times but was always, for that very reason, a subject for artistic representation as well. So it is no accident that the earliest sculptured works of art, the stone carvings of Ice Age man, are of the Great Mother. It is generally admitted today that these carvings, whose distribution extends from Spain to Siberia, have a religious or cultic character. These figures of the female deity therefore stand at the very center of the earliest human culture. The fact that this deity is the Great Mother who gives nourishment, shelter, and security makes her the mistress of life and fertility, and her cult representation—of her cult we know nothing—is the earliest expression of the emergence into consciousness of mankind's experience of the power of motherhood over life and fate. Religious art and the ritual associated with cults have always been symbolic anticipations of a conscious knowledge that came later.[10] The sovereign power of motherhood de-

termined the earliest phase of man's development, and only later, with the growth of consciousness, was it superseded and overlaid by the significance of the father and the patriarchal values connected with the father archetype. Today a new shift of values is beginning, and with the gradual decay of the patriarchal canon we can discern a new emergence of the matriarchal world in the consciousness of Western man. The archetypal character of great art is often shown by the fact that the same content—in this case the mother archetype—goes together with an outward form whose identity over the millennia makes the primordial sameness of the human psyche strikingly evident.

While the similarity of the Great Mother figure to the neolithic mother figures from France is certainly striking, Moore goes beyond the archetypal pattern by providing this overarching mother figure with a child. In spite of its independence, the child remains intimately connected with the mother. The crossbeam joining the two is an expression of the indissoluble unity that has always preoccupied Moore and that he seeks to embody in ever new forms. ₂₁ ₂₂

The connection of the mother with the child represents an unconscious identity and is known in analytical psychology by Lévy-Bruhl's term *participation mystique*. It is the same constellation as that which certain modern American psychologists call "empathy." This original relationship of child to mother is realized

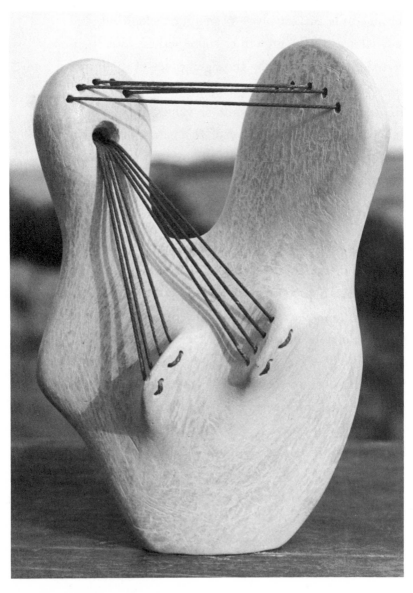

23. MOTHER AND CHILD. *Model, in
plaster and twine, for a cast in
lead strung with wire.* 1938. H. 5″

24. MOTHER AND CHILD: DRAWING
FOR A SCULPTURE IN WOOD AND
STRING. *Chalk, pen, and water color.*
1940. 11 × 15"

afresh in every childhood and seems to us the prototype
and archetype of all human relationship. We have
called this dawn phase in the development both of man-
kind and of the child "matriarchal" because it is domi-
nated by the mother archetype, and we recognize the
matriarchal or, in the language of psychoanalysis,
the "pre-oedipal" stage of childhood development as
the basis of all further psychic growth, whether sound
or morbid. By matriarchal and pre-oedipal we mean
that at this stage the father does not yet have any de-
cisive significance. Moore's mother-and-child groups,

too, like his Madonna and child, are fatherless. Only in his later work do the family groups appear, in which the father plays a part.

Although we shall not be considering the "stringed figures" until later, a few words must be said here about the mother-and-child groups in this category. The figure from the year 1938 and its companion drawing from the year 1940 are valid realizations of the psychological *participation mystique* between mother and child. What is so unique and impressive about these strange figures, what makes them so convincing both psychologically and plastically, is that the separate masses of material are joined to one another by the interconnecting strings in such a way that—apart altogether from the formal achievement—the living current of relationship becomes visible reality, and psychological truth becomes concrete fact. The streams connecting the child's eyes with those of the mother are like ghostly, spiritual bridges, incorporeal yet visible, occupying yet creating space: they form the upper horizontals of the structure. Simultaneously a current of desire, like lines of force, streams from the mouth of the child to the mother's breasts, whose nonbodily yet dynamic presence sets up the diagonal connection that vivifies the conjoined masses of mother and child. Utterly nonconcrete, but utterly convincing in its distribution of masses, curves, and lines of force, and perfect in its kind, this group is one of the greatest mother-child conceptions of our time.[11]

The drawing from the year 1940, with the mother
sitting and holding the child on her lap, shows the same
stringed currents of interaction and relationship. Here
the child is no longer supported by the mother's arm,
nor does it hold fast with its own arms: its *participation
mystique* with the mother rests entirely on the currents,
visualized as strings, that unite the fields of force of
mother and child. (Later we shall consider the substitution of the outward curve of the breast by the inward-curving hole that represents it.) The connection
between the two figures flows from the center of the one
to the center of the other. It is, in fact, an archetypal
idea that the unconscious bond between people in a
state of *participation mystique* has its seat in the solar
plexus ("sun web"), which is localized in the center of
the body, just as shown in the drawing. The solar
plexus is the center of the "sympathetic" nervous system, whose function is to mediate the "sympathies,"
the participation of living beings with one another.
Here again one can only marvel at the profound intuition of the artist, who in his visionary grasp of these archetypal relationships made visible the Invisible.

IV

OF THE two big themes in Moore, the mother-child motif expresses not only the dependence of the child on the mother but also that of man on nature and of the individual on all life—if one wishes to translate forms into necessarily inadequate concepts. The reclining figure, on the other hand, is a representation of this mighty "Other," of the female principle in the loneliness of its self-contained existence. We have seen how the transformation of the personality of a reclining woman into the transpersonality of the Earth Mother was expressed by her recumbent body changing from the organic into the recumbent inorganic body of the landscape. In the 1933 *Reclining Figure,* the mountain peaks of the two breasts correspond to the precipices of the knees, and the reduction from the human scale is indicated by the melting down of the head, which, as the emblem of individuality, has dwindled to a knoblike or bulbular process that functions only as a formal quantity.

The motif of the head, its melting down as well as its enlargement beyond what the head normally signifies, plays an important role in Moore's work. It is as if the emotional accent affected this part of the body more

than any other. When, in the works so far discussed, the accent lies on the body, on its formation and transformation, then the head gets smaller, shrinks to a mere appendage, an offshoot of the trunk that barely needs suggesting. But when, for whatever reason, the emotional accent falls on the head, then this organ, as we shall see,[1] becomes a world that is independent of the trunk and even starts leading a singular existence of its own.

Whereas the mother-child motif was "spiritualized" in a way typical of the trend toward abstraction, the transformation of the reclining figure during the same period follows a different course. Here too there is an accentuation of the structural, mathematical element, as is particularly evident in the sketches for unexecuted *e.g., 25* works. But we also find, in the years when Moore was experimenting with abstract art (1933–37), that the purely feminine element is more in abeyance than at any other creative period. This is because the feminine, by reason of its archetypal nature, pertains to the world of the organic. Since, for Moore, "asymmetry is connected also with the desire for the organic (which I have) rather than the geometric," the geometry of nature is integrated into the organic as only a partial aspect of it.

One might suppose that stone, by its very nature, would lend itself particularly well to geometric and constructivist forms of art, but Moore's work proves

25. IDEAS FOR SCULPTURE IN METAL
Pen and wash. 1938. 15 × 22"

rather the contrary. This can be seen very clearly when, with the discovery of the hole, the "breakthrough," and the cavity, Moore opens out a specifically sculptural world of stone that is not geometric but natural and organic in just that sense emphasized by the above quotation. Natural stone, "living rock," is part of the feminine world of nature with its asymmetry, its unsuspected rotundities, valleys, and curved surfaces. The natural organic quality of stone, of its formation, which follows uncontrollable laws, is in our sense of the word "matriarchal." The sculptor's own description of the creative process, which was associated for us with matriarchal consciousness, finds expression first in the

living organic forms imparted to the stone, and second in a willingness to let the creative act be guided by the nature of the material—an attitude that is more akin to passively receptive obedience than to a purposive and formative act of masculine consciousness.

The antithesis of the rounded, organic nature of the feminine is the constructive, geometrical striving of the masculine mind, which with its calculating and measuring consciousness violates the feminine qualities of matter and molds it to its own law. It is no accident that the early figure from the year 1934 is almost the only 26 example in Moore's work of a geometric, cubistic creation, and, with its pronounced angularity, is more like a masculine than a feminine deity.

When, however, Moore gets down to his two basic themes in the great works of this period, the abstraction is, as it were, swallowed up in the archetype of the feminine, and there now begin the depersonalized and transpersonal representation of the archetype in sculpture and also the transformation of the remnants of naturalism into forms and contents of a specific kind.

The dehumanization of the object, which began with the female body turning into hills and valleys of terrestrial shape, is carried a stage further: Moore now starts loosening up the compact unity of masses that sculpture, as previously understood, had fused together. "A piece of stone," he says, "can have a hole through it and not be weakened—if the hole is of a

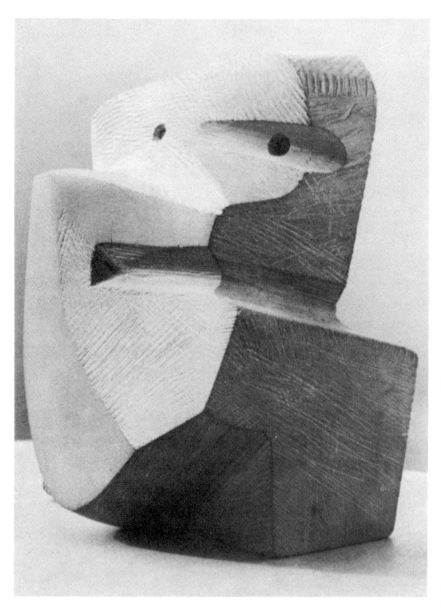

26. CARVING. *African wonderstone.*
1934. H. 4″

studied size, shape and direction. On the principle of the arch, it can remain just as strong. The first hole made through a piece of stone is a revelation. The hole connects one side to the other, making it immediately more three-dimensional. . . . The mystery of the hole —the mysterious fascination of caves in hillsides and cliffs." [2]

To this the author of our much-quoted catalogue, Mr. Sylvester, remarks in the psychologizing manner so popular today: "But its deepest meaning, of course, lies in its sexual symbolism." And he goes on: "It is worthy of note that, when discussing the formal value of holes, Moore considers the hole as an aperture piercing a form, but as soon as he refers to its poetic value he suddenly identifies the hole with the cavern." [3]

This glib "of course," like the alleged "sexual symbolism" in Moore and the "poetic value" of the hole, must claim our attention because from such misunderstandings it may become clear what it is that makes Moore's art archetypal and why the terminology of Mr. Sylvester, who so earnestly endeavors to be fair to Moore, goes so sadly astray on these crucial points.

After all we have said about the significance of the archetype of the feminine, no one will imagine that we have overlooked the sexual meaning that the hole can have and always has had. It seems to us, however, that the real problem only begins where the banality of this time-honored fact leaves off. For Moore can hardly be

described as a psychopathic personality who is obsessed with sex and sees holes everywhere, even where none exist in reality, and makes this the distinctive feature of his art. Nor can one speak of an "unconscious" compulsion in an artist who is so very wide awake and not in the least given to somnambulous creation—as his essays on sculpture show—and who is certainly not unaware of the drab psychoanalytical statement that the hole is a sexual symbol. When Moore, therefore, identifies "hole" with "cavern," it is a question not of "poetic value" but of a very real symbolism whereby, as Moore himself explicitly says, the feminine is transformed into the earth archetype. If he speaks of the "mysterious fascination of caverns in hillsides and cliffs," that is a genuine and not at all unconscious description of an inner constellation, and the fascination refers to the turning of interest, under the guidance of the unconscious, upon the partially unconscious archetype of the feminine. Here again one can only speak of a partially unconscious process; for although the unity of this archetype, as seen in the determinative effect it has upon Moore's work, may have remained unconscious to the artist, he is no more unconscious of the fact that his work aggregates round this center than a Madonna painter would be of the fact that he paints Madonnas. The only difference is that the Madonna represents a ruling value of the cultural canon, whereas Moore's work is dedicated to an archetype that is only just looming up on the conscious horizon of our age.

The relation of the artist in general to the mother archetype, particularly in our age, when this archetype is strongly emphasized in the collective unconscious, has been dealt with elsewhere in a number of separate studies.[4] However, the relation of the creative individual to his childhood, the time when everybody has archetypal experiences, requires special psychological attention and an understanding that goes deeper than the usual psychoanalytical reduction.[5]

The skeleton key of psychoanalysis would reduce Moore's work to a repetition compulsion and would explain the driving force of his existence as "nothing but" the early infantile sexual curiosity that, pathologically, he has failed to overcome. Even if his work was interpreted as a "sublimation," such a view would still leave Moore an immature personality with a fixation on contents that ought to have been overcome in the normal course of conscious development.

The artist's fascination by the mother archetype is, however, by no means only a personal phenomenon of his individual history; it represents an advance into a psychic realm that is of fateful importance not only for himself but for his whole age, if not for mankind in general. We have repeatedly emphasized that man's relation to nature and the creative forces of life is reflected in the mother archetype. In an age when Western man, through his exaggerated respect for the patriarchal spirit and the techniques it has engendered, is in danger of losing contact with the roots of existence, there

has arisen in the unconscious, in accordance with a general psychic law, a compensatory tendency that is reactivating this feminine, maternal earth-nature aspect, which has been too much repressed.

Moore's work—and not his work alone—is the clear expression of this countermovement through which the hitherto unconscious power of the mother archetype is beginning to assert itself in all its manifold meanings and so to force its way into the collective consciousness. It is precisely through this compensatory function that Moore demonstrates his importance and the importance of every great artist, whose effect lies chiefly in funneling back into culture the missing but much-needed values he produces out of his creative unconscious.[6]

In earlier times archetypal productions had their form more or less fixed by the prevailing canon of values, and only relatively minor variations were permitted to the artist. But the closer we come to modern times, the more strongly the individualization of humanity advances, and the individuality of the creative artist plays a correspondingly greater role. In the course of his development and at the critical stages of his individuation, the operative archetype in his unconscious is molded by him into ever-new forms, so that, in the case of Moore, it is not just an established aspect of the feminine archetype that takes shape through him; it is rather the polyvalence of the archetype—that is to say,

its ever-present potency and diversity—which leads to new and different realizations.[7]

Looking at the wood carvings from the years 1936 and 1939, which are characterized by the "opening out," "the disruption of the volumes of the female body by holes, cavities and concavities,"[8] we must go a long way back in order to get at the inner meaning of the brilliant innovations with which Moore has enriched modern sculpture. 27–29 30–32

In the 1935/36 wood carving the optic unity of large masses is thrown into relief. Already the impersonal modeling of the figure is so strongly emphasized that the head functions only as an unindividual formal unit, while the body has been metamorphosed into something huge and mountainous. It is a peculiarity of Moore's work that the impression it gives of being superhuman and even gigantic has nothing to do with the actual size of the object. It is no accident that one can easily imagine the small scale of this carving enlarged to monumental size, and this would be quite in keeping with Moore's intention. "If practical considerations allowed me, cost of material, of transport, etc., I should like to work on large carvings more often than I do. The average in-between size does not disconnect an idea enough from prosaic everyday life. The very small or the very big takes on an added size emotion."[9] 27

This stepping beyond the bounds of everyday life through concentration on the formal elements and the

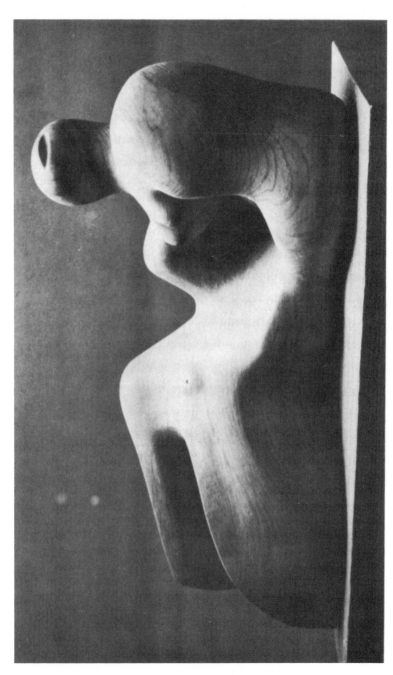

27. RECLINING FIGURE. *Elmwood.* 1935/36. L. 35"

use of abstract simplification exemplifies the trend toward the archetypal and transpersonal. The opposite of "prosaic everyday life" is the archetypal world, which as the original "unitary reality" [10] represents a world that for our differentiated consciousness is real only as a borderline experience. Here we can do no more than try to describe this concept of "unitary reality"—which is so important for analytical psychology—and then only insofar as it concerns artistic creation in general and that of Moore in particular.

Normal everyday life is conditioned by our ego-centered consciousness, which knows only a reality polarized into outside and inside, a world of objects that the ego, so far as it is conscious, confronts as a separate subject. Primitive man and the child, the inspired artist and creative individual, experience a completely different reality, and it has always been the aim of great art to conjure up and give shape to this unitary reality underlying the polarized world we ordinarily know.

There are, however, many ways of approach to this unitary reality. Not only the art but the religion of every age has tried, within the limits set by the time, to gain access to it. But it is only by transgressing these limits, whether of the time or the personality, that the image of the other, more complete reality becomes visible. In this sense the unitary reality always has an aspect that is relative to the reality of consciousness and is necessarily seen as the "other side" and the "wholly other."

When man's consciousness is fixed fast in a spiritually medieval world, the newly discovered unitary world glows with all the colors of earthly reality, as in the Renaissance from Giotto to Leonardo. When, on the other hand, the fixation on the multiplicity of the concrete world of objects distorts and clutters up the image of reality, as it did in the Netherlands at the time of Rembrandt, the unitary world breaks through in a burst of light from the other side, which seems to transfigure the things of this world. But when a technical world like ours, which is cut off from all its psychic and natural roots, fills the whole horizon of consciousness, then the unitary world shows a terrifying, daemonic, and archaic face, and proves to be full of tremendous powers—divine or devilish—of which our godless world of consciousness knows nothing.

The inexhaustibility of this unitary reality can only be described as that of an archetypal and mythological world, for it is only in the polyvalence of the archetype, if at all, that we can hope to grasp its many-sidedness. At the same time, it is animated throughout by a current of emotionality: it not only moves but can be moved by our emotions. The *participation mystique* between mother and child that we have tried to illustrate is here the absolute law. Everything is connected with everything and acts on everything; there is no inside that does not appear as outside and as acting on the world, no aspect of the world that is not charged

with psyche and psychically connected. This world, which the child experiences, is a mythological world, because in it the great transpersonal figures are at home, appearing now as a tree, now as a pebble, now as a man, each containing within itself the whole wonder of unitary reality, which is bodied forth through the emotionality of the child psyche.

When the artist, when Moore, puts his figures into reality, it is never the reality of our consciousness and of everyday. Always these figures belong to another world than the "normal" one, and always they have the effect, in our everyday world, of an invasion from another dimension of being. What strikes us as archaic, primitive, abstractly simplified, and in the representational sense "unnatural" and "unreal" in Moore's figures is a pointer to this other world of unitary reality, where our differentiations of consciousness and our distinctions between large and small, outside and inside, no longer apply.

The peculiarity of Moore's "matriarchal" mode of creation is that he does not use matter as the raw material of his vision and shape it by force—in the way, for instance, that Michelangelo impressed the mythical world of his vision forever on the West, which thereafter saw God the Father in his, Michelangelo's, image. Rather, through Moore's yielding to the intention of the material, of the wood, rock, or bone, the world changes shape under his hand; he leaves the sphere of cerebral

28. RECLINING FIGURE
 Elmwood. 1936. L. 42″

29. DETAIL OF 28

consciousness and penetrates to a deeper dimension, closer to the unitary reality, where inside and outside are one. This is seen most clearly, perhaps, in his wood carvings.

Even in the illustrations it can be seen how the wood is treated as living matter in motion, and how the flow of the grain heightens the plastic effect of the carvings, indeed to some extent makes it possible. Following the line of movement as it adapts itself to the natural graining, one has the impression that the carving was imagined that way by nature, by the wood itself. Observe, in

28 the elmwood figure, the broad sweep from shoulder to
 arm; it is conditioned by the grain of the wood—the
 artist has only followed it. So, too, with the lines rip-
29 pling down from beneath the breast to the left leg.
 This obedience to the wood, also apparent in the mod-
28 eling of the right knee and leg, heightens in its turn
 the abruptness of the cleft through which the inside of
 the left leg plunges violently into the chasm between the
 thighs.

 The symbol of the chasm has not been chosen acci-
 dentally, for the transformation of the female body into
 landscape has become reality in this carving too. Per-
 haps it can be seen best in the "breakthrough" below
 the breasts into empty space. What Moore said about
 making a hole in stone is equally true of wood: "On the
 principle of the arch, it can remain just as strong." Just
29 below the fourfold curve of shoulders and breasts, the
 flow of the grain runs into a passage that, with the ma-
 jestic quietness of a mountain archway, leads out into
 the open, leaving the upper parts overhanging like mas-
 sive conformations of nature.

 And here we come to a new formal principle that
 Moore has developed more particularly in his wood
 carvings, though, as we shall see, it does not apply to
 them alone. Perception of the object's surface, the
 grasping of it as an optical image, is not the only factor
 operative in an experience of Moore's sculpture. He
 takes us, so to speak, beyond or underneath the surface

image into an ontogenetically and phylogenetically earlier stratum where haptic or tactile experience of the body plays a dominant role. By making the grain of the wood serve as guiding lines for the eye, he conveys, more powerfully than any other artist has done before him, an experience of the tactile surface of the object, its very feel. The movement of the eye becomes a sort of stroking movement, a caress, through which we experience mass and volume with the sense of touch, that is, as a true spatial structure. In this way we are inducted into an adequate experience of sculpture as a spatial object to be touched, whereas the older plastic method aimed at an optical experience of wholeness that is accomplished exclusively by the eye, the symbol of consciousness, and that presupposes and requires a beholder standing opposite at a distance. In this optical confrontation the conscious separation of subject and object is complete, and this is the very thing that Moore, consciously or unconsciously, wishes to avoid. By forcing us into a tactile experience, he calls awake the archaic—and infantile—experience of man, who now lets his touch play lingeringly round the immensity of woman.

But the experience of depth thus afforded goes even further. Tactile experience, as opposed to visual experience, is blind and has to rely on the sculptural values of the world of the body—round and angular, curved and hollow, smooth and hard. The combination of visual ex-

perience with guidance by the lines of touch produces a strange alteration in the experiencing subject. As in *Gulliver* or in a fairy tale, he is changed into a tiny creature moving about on the surface of this body like an animal on the surface of the earth, and the sensitive beholder is compelled, as he follows the lines of touch in the wood, to experience the great archway through the recumbent figure from below, as if he were in a mountain cavern. This metamorphosis of the experiencing observer into something small, which walks about on the body of the figure and feels its hollows, arches, turnings and passages, valleys and mountains, like a landscape, makes these figures overlifesize. As comparison of this piece with the 1939 carving will show, this experience is not induced simply by the photographic enlargement of detail; the detail only illustrates it. The flow of the grain as tactile guiding lines and the resultant dwarfing of the subject are clearly apparent in the details, but so too is the effect of both in transpersonalizing the sculptural detail into an overlifesize landscape.

"The mystery of the hole, the mysterious fascination of caves in hillsides and cliffs." Elsewhere and in another connection [11] we have discussed this fascination, which lured the men of the Ice Age into the perilous depths of mountain caves where they painted their murals. It is the mystery of the secret path of initiation that everywhere leads human beings into the darkness, and

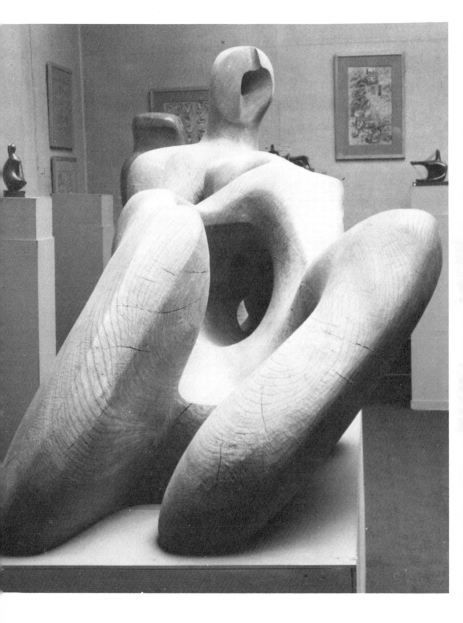

30. RECLINING FIGURE
Elmwood. 1939. L. 81"

in the experience of this darkness, which is the darkness of the unconscious, promises them the discovery of a hidden treasure, the unveiling of the secret. It is therefore no accident that the earliest cult places as well as the latest sites of the mystery religions were caves, and that the "night sea journey" of the sun, the principle of consciousness, into darkness, and its rebirth from it, is perhaps the oldest archetypal form of mystery known to mankind.[12] The fascination of caves for the group and the individual alike, for primitives and for us too, is connected with the archetype of the Great Mother, who from the remotest times has been the Earth Mother presiding over caves and mountains. To penetrate into the "inside of nature," to unravel her deepest secrets through an experience that today we would call an "inner" one, an experience of psychic transformation— that is the hidden meaning of all those arcane paths leading into the "womb" of mystery. It is absurd to try to reduce this profound inborn striving of man to discover and understand the mystery of the Great Mother to the sexual curiosity of the infant. The contrary is the truth. This infantile curiosity indeed exists,[13] but folded within it, as in a bud, there lies the whole endeavor of Homo sapiens to fathom the mystery which at this early stage—both archetypally and ontogenetically—is intimately connected with the mystery-encompassed existence of the mother.

In this sense the hole and the cave are anterior to the

mother, and the emptiness that invites investigation is a more primordial thing than the female genitals, which in primitive cultures, where the cave and the path of initiation were the central secret, certainly presented no mystery whatever. Hence the "mystic way" with all its fascinating numinous symbolism is something quite different from "the way of a man with a maid." However closely the numinous experience of sex and sexual intercourse approximates to the archetype of the mystic way,[14] it has always been regarded as a normal and even prosaic event; and man's path into woman was at all times distinguished from the supernormal and sacral path of the mysteries, even though the latter was practically always bound up with the archetypal "womb," with entry into it and rebirth from it.

Here again the archetypal symbolism, whose meaning transcends the personal, is obvious. Being contained in something maternal that is greater than oneself, and emerging from it regenerated, are genuine psychic emotions felt by everyone who enters a world transcending his ego consciousness and is transformed by this experience of mystery. But toward that which surrounds and contains him he feels childishly small, and this feeling awakens echoes of his own infancy, when he groped his way about the mother.

We know, however, that this world of childhood is characterized not by the personal experience of the conscious ego but by the experience of totality. The

mythological experience of the child, his magical correspondences between world and body, inside and outside, etc., give him an overwhelming sense of a unitary reality not yet polarized into opposites, and thus form the basis for the adult's experience of mystery. It is in this sense that we have to understand Matthew 18 : 2: "Except ye become as little children, ye shall not enter into the kingdom of heaven." In earlier times the content of the mysteries was celebrated by the community in cult and ritual, and the cult image was handed down over the centuries and worshiped in fixed form. The modern artist approaches this world of the numinous as an isolated individual with all his limitations, and his groping attempts are unaccompanied and unformed by any valid tradition. He has to discover, in himself and by himself, everything that has been lost to our world, and often enough he must pay with his life and health for the risks he takes in not being initiated by a "knower," in having to grope his way alone into the dark womb of the unconscious.

As we have seen, this groping has become extremely concrete in Moore's sculptures. Their inner tactile aspect enables one to experience in a unique way the fascination of being led into the darkness, the changing of 30 the body into a mysterious cavern, and of the whole fig-31, 32 ure into the Earth Mother. It is a magnificent and entirely new representation of the feminine archetype as woman and earth at once.

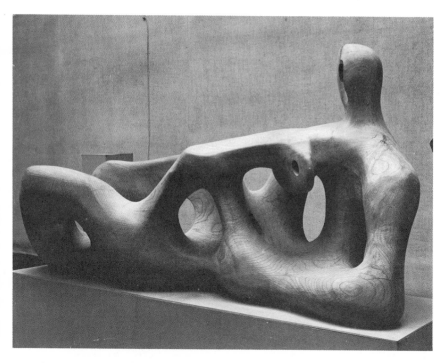

31. ANOTHER VIEW OF 30

To every unbiased observer who is capable of learning from experience, it is just the cavernous quality of these figures that demonstrates the transparent inadequacy of the statement "but its deepest meaning, of course, lies in its sexual symbolism." The womb is completely emptied of all sexual significance; not only have the female genitals been hollowed out into a uterus, but the whole body has been converted into a cavern and cannot be experienced as anything else—it has become a true symbol of the "container" in which one can wander about like a small child, provided that the dark

30

and uncanny character of the cave is not too frightening. This is never the case with Moore; for in all his reclining figures, which, as he himself says, belong out of doors, in the daylight, the play of light and shadow in the hollows, passages, mountains, and hills is never somber or menacing, as they are all in a psychological sense "open." *e.g., 31*

The haptic or tactile experience of the female is undoubtedly a return to the child's early experience of the mother's body, and from this standpoint too the reclining figures prove to be mother figures. Nevertheless, it is worth pointing out that in no member of the animal kingdom except man is the haptic side of the sexual relationship so accentuated as in the love play of the adult. For this reason the haptic element in the experience of the body's form is in no wise to be regarded as regressive or infantile. The dominant factor in the haptic experience of the child, to which Moore's art reverts, is the peculiar hierarchy of magnitudes in which the subject feels small, dependent, and attached, and the mother's body feels like a great world, the source of life and warmth.

V

IN ORDER to find symbols that give adequate expression to the archetypal and transpersonal qualities of mankind's childhood experience, as we see it uniquely embodied in Moore's work, we would have to go far back into human history. Let us take, as one example 33 among many, the 1941 drawing of *Two Sleepers.* In this picture the sleeping bodies are not only buried but "gone to earth" again, as though they had sunk back into the clay from which they were originally formed. The cloth covering the heads of the sleepers has only to be drawn down a little further and they would be wrapped like the dead in the shroud of the deathly mother. The wide-open mouths call up an archetypal image that complements the idea of the body as something hollow: the image, known all the world over, of the "soul" that comes into the body from outside and dwells in it as in a cave or shell, or—negatively experienced—as in a prison or a coffin. This soul is also pictured in myths and fairy tales as an animal that steals out of the body at night and wanders about. An analogous idea is that of the soul departing at death in the shape of an animal and thereafter leading an existence independent of the body.

33. TWO SLEEPERS. *Chalk and water color. 1941. 15 × 22"*

Frazer has put together a mass of ethnological material on this subject in *The Golden Bough*.[1] The wandering soul, which can go astray and get caught by magicians and evil spirits, is always a separate thing that can come into or go out of the body because it is of a different nature and has no abiding connection with it. The ideas of incarnation, of the soul taking a body, and of ecstasy or possession, of being "beside oneself" or seized by a "strange" soul, are expressions of this polarization of the body as a vessel into which a soul enters like an animating principle. What the psychoanalysts interpret personalistically as a "uterine fantasy" is

based on this archetypal conception, where the body is experienced by both men and women as the tenement that houses the soul animal.

The creeping in and out of this soullike entity is connected with another problem whose significance is becoming more and more obvious in Moore's sculpture, and that is "outside" and "inside," the way they are interchanged and made relative. Haptic experience leads, as we have seen, to sculpture being *felt* with all its hollows, passages, crannies, and apertures, so that the female body opens out into a landscape, its elevations being perceived as hills and mountains, and its depressions as valleys and ravines between mountain masses. This wandering over the inside and outside of the Primordial Feminine results in an effacing of boundaries, an abolition of the clear division between inside and outside that is characteristic of our cerebral consciousness.

Tactile experience of the female in sculpture has its parallel in the early mythological experiences of mankind, when man felt the earth to be a feminine being, whose mountainous breasts he climbed, whose hollows and openings were chasms and caves into which he penetrated, and in whose body he was finally buried at death. Even today, and not only in myths, fairy tales, and legends, these primitive experiences are still alive in us and are often called awake in dreams.[2]

This effacing of the boundaries between inside and

outside, or rather their changing into one another, is all part of the unitary reality of *participation mystique,* in which analogies are not correspondences merely, but are experienced as true identities. Hence, if earth and woman are identical, this does not mean that a causal relation obtains between them, but that, since sexual intercourse and plowing the field are the same thing, the one can stand for the other in ritual. Man's magical power consists in the simple fact that he is the center of the world to whom all things are related, and that everything that happens in the world depends on his ritual actions. Here again what happens inside man is the same as what happens in the world outside; there is no reflecting consciousness to set up valid or—to later reflection—invalid causal relationships.

In this sense Moore's sculptures actually *are* the earth for an ego bound to the unitary world by haptic experience, and are not just models or symbols of it. And it is only from this depth-psychological standpoint that we can understand what Moore once said in an interview: "All experience of space and world starts from physical sensation. This also explains the deformation of my figures. They are not at all distortions of the body's shape. I think, rather, that in the image of the human body one can also express something nonhuman—landscape, for instance—in exactly the same way as we live over again mountains and valleys in our bodily sensations. Or think of the basic poetic element in metaphor: there

too we express one thing in the image of another. It seems to me that I can say more about the world as a whole by means of such poetic interpenetrations than I could with the human figure alone."[3]

As a result of this substitution of inside for outside, the interior wall of the body is experienced as something external, and, conversely, the hollow, cuplike character of the mother's breast predominates over its convexity, or is at least simultaneously suggested. Thus and only thus can we understand the strange phenomenon that in the works of Moore's middle and late period the breast can also appear as a hole leading into the body. Whereas in the late terra-cotta *Family Group* from the year 1946 the absence of a breast in the male figure only emphasizes the broadness of the shoulders, a similar lack in the female—which we find in a number of reclining figures—would make her nutritive function impossible. But the child's fixation on the mother's breast does not seem to give sufficient expression to her feminine intensity. Hence the other breast, being represented as an opening into the body cavity, activates all the associations Moore is most concerned with, and this motif of the breast as an aperture opens out the whole background of woman as a vessel, cave, or chasm, the container that shelters and brings to birth. Here we may remind the reader of what we said at the beginning about the contrast between form and content not being applicable to Moore's

34

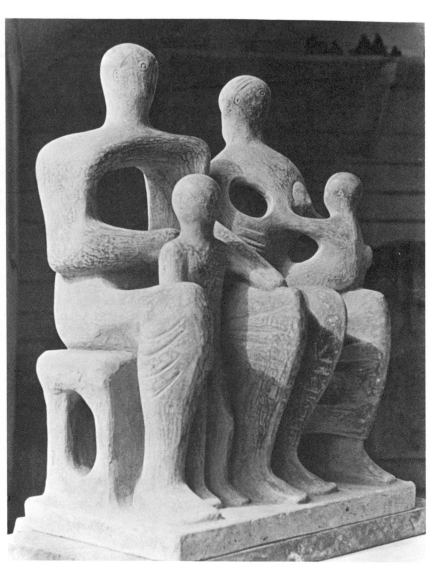

34. FAMILY GROUP. *Terra cotta. 1946.* H. *17⅜″*

work. In his case they are intimately connected with one another, and a purely aesthetic viewpoint that stresses the form without understanding its connection with the subject it represents is just as inadequate as a one-sided appreciation of the content, which fails to recognize that Moore's archetypal subject has inspired him to create continually new forms that are unique in the world of sculpture.

Similarly, our remarks on the transpersonality of the earth goddess and her significance are confirmed in a curious way, which, just because it is so unexpected, is all the more convincing. Owing to the war, Moore was obliged to give up his work as a sculptor for a time and to devote himself mainly to drawing. "Quite against what I expected I found myself strangely excited by the bombed buildings, but more still by the unbelievable scenes and life of the Underground shelterers." [4] This sentence stands like an epitaph over the wealth of drawings he produced between the summer of 1940 and the end of 1942.

In these shelter drawings Moore was given a unique opportunity to see his inner image of the archetype of the feminine as the sheltering cave in the earth realized all around him in actual fact. With the collapse of the modern civilized world an archaic, primitive world of cave life suddenly appeared in its very midst, and the long-forgotten situation of human beings crawling for shelter, like worms, into the womb of the earth and

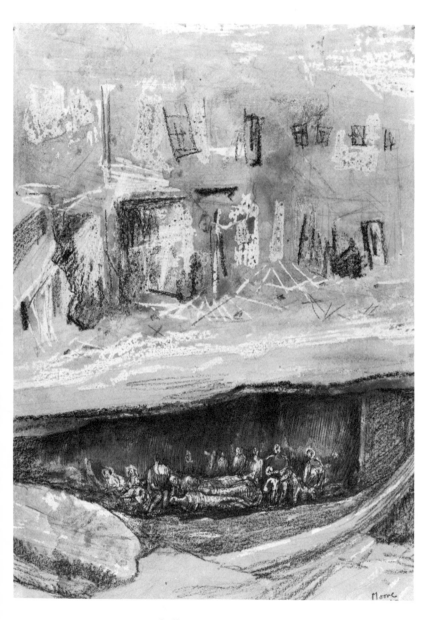

35. GASH IN ROAD. *Chalk, pen,
and water color. 1940. 15 × 11″*

being swallowed in its abysses became an all too topical reality. Just as a man stirring up an ant heap with his stick uncovers the swarming life underground, so the *Gash in Road* lays bare the termitelike subterranean existence of earth dwellers who, driven by fear, creep back into the cavernous womb of the Great Mother. There they lie in endless rows, anonymous cocoons, with the wall of the earth's uterus arching over them. Born of earth, supported by earth, stretched out upon it and overpowered by it, they have practically become earth again. Are they living sleepers or dead? With these *Sleeping Shelterers* and the *Four Gray Sleepers,* as also with the *Two Sleepers* mentioned above and many other pictures of Tube Shelters, it is difficult to tell. In the *Shadowy Shelter* the white lines of the blankets' folds shine so spectrally in the darkness that they make one think of a heap of skeletons, and in another drawing, *Group of Shelterers,*[5] the figures look like shapeless mounds of clay.

The shelter pictures are full of reclining figures and mother-child scenes, as though only these two motifs could survive in the world underground. The enfolding earth character of this underworld is reinforced by the motif of a blanket—it may equally well be a swaddling cloth or a winding sheet—that is repeated in the most varied ways.

Since the garment in which the child is wrapped accentuates the cavelike character of the mother, it takes over, like the white coverlet, the same formal role

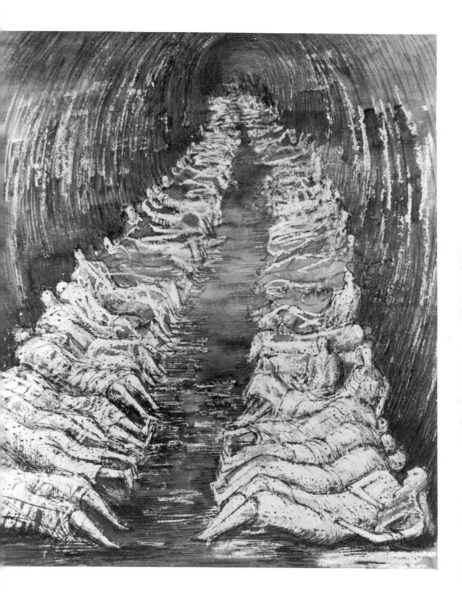

36. TUBE-SHELTER PERSPECTIVE
Chalk, pen, and water color. 1941.
18¾ x 17"

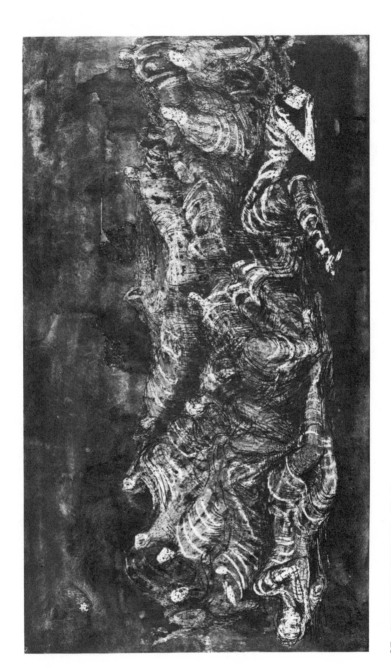

37. **SHADOWY SHELTER.** *Chalk, pen, wash, and water color. 1940. 10¼ × 17¾″*

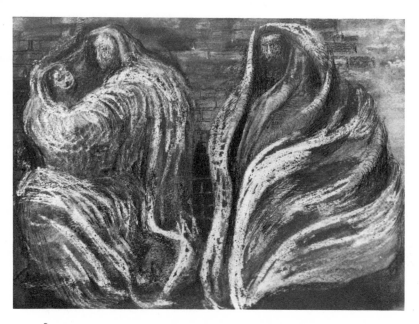

38. SHELTER SCENE: TWO SWATHED FIGURES.
Chalk, pen, and water color. 1941. 11 x 15"

of uniting mother and child that the stone once had. 18
The swathing blanket molds the sleepers closer to the 33
earth; it forms a maternal shelter for them to nestle un-
der, as in the *Pink and Green Sleepers,* where a fold of 39
blanket belonging to the woman sleeper spreads out
like a green wing beneath which the red sleeper re-
poses.

That this dominance of the archetype of the femi-
nine in the shelter drawings is not accidental is proved
by a curious counterphenomenon. During the war
Moore was commissioned to make drawings of miners
at work, and one might have thought that the arche-

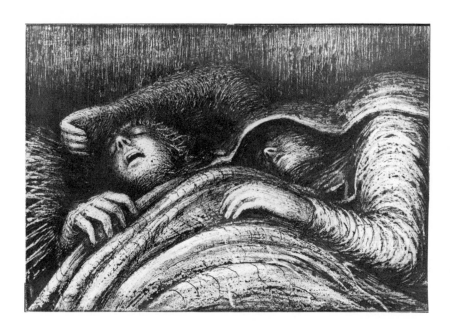

39. PINK AND GREEN SLEEPERS.
Chalk, pen, and water color. 1941. 15 x 22"

typal character of the interior of a mine would again
stir his imagination in a fruitful way. But, compared
with the shelter drawings, the drawings of miners are
cold and lifeless. This fact, which seems rather odd at
first sight, becomes understandable when we remem-
ber that Moore, whose father was himself a miner, has
never liked to draw men, and that miners could not
activate the unconscious archetypal connection be-
tween the world underground and the feminine. Mas-
culine activity, even when operating inside the earth,
stands outside the world of motifs that almost uni-
formly determine Moore's work.

The sudden irruption of the shelter world led to a renewed activation of the feminine archetype of the earth and the underworld, but the basis for any genuine experience of this great Earth Mother is the passive relationship of human beings to the cave, the motif of refuge in it, of protection and sleep. For this reason there is very little active movement in the shelter drawings. On the other hand, the miners hacking away at the coal face are too much bound up with the masculine activity of consciousness to make the earth archetype come alive. This accounts for the weakness of Moore's mining pictures. They are "social documents" of our everyday world, not archetypal visions of human beings in relation to the earth.

We would emphasize this in direct contrast to Herbert Read, who is inclined to derive Moore's work in a personalistic, psychoanalytical manner from childhood memories of mining. The decisive phenomenon is that, in spite of the mining world of the father in which he grew up, the archetypal cave world of the mother nevertheless managed to assert itself to such effect.

Two problems obtrude themselves when one considers the psychogenesis of the creative individual as exemplified by Moore. The first is: Can one attribute any decisive significance to the outward impression made by the miner's world on the imagination of a child? The second is the obvious psychoanalytical

"solution" of the problem, that with Moore it is simply a case of an Oedipus complex caused by fear of the father, and of regression to the pre-oedipal mother—in short, of a flight into the maternal uterus.

We know that the mother archetype remains dominant in a number of creative individuals and that the normal development of Western man, when the dominance of the mother archetype is superseded by that of the father archetype, does not take place in them, or only incompletely. There are good grounds for supposing that this overaccentuation of the mother archetype corresponds to a constitutional activation of the collective unconscious, resulting, among other things, in a strong intrapsychic tension between conscious and unconscious. Besides that, the activation of the unconscious produces a preponderance of unitary reality in the experience of the child, and hence a special activity of the unconscious world of symbols and the fantasies they feed.

According to the personalistic theories of psychoanalysis, the creative individual would be formed by certain impressive experiences in infancy and could therefore be "trained" through the constellation of similar experiences. All psychological probability and experience, however, argue against such a hypothesis, though we would not deny that impressions of this kind may help or hinder innate developments.[6] But just as, with countless children, exactly the same "mining ex-

periences" do not activate the mother archetype and do not produce any creative work, so no such influential outward factors can be discovered in a large number of creative artists. The lack of agreement between the personal reality of the parents and the child's psychic apperception of it is very striking and is one of the central problems of child psychology. Psychic development seems to be archetypally directed from inside, and when, for example, the time has come for a child—genetically speaking—to sever its ties with the mother and the maternal world, the mother will appear a "witch" quite independently of her "real" behavior. For the sake of the child's development all the actual facts of the situation are now, necessarily and meaningfully, worked out in accordance with the "witch" idea. If the mother is really "wicked," then to all intents and purposes she *is* a witch; if she is "good," she is a witch just the same, whose very goodness beguiles her offspring into remaining childish. The fact that at certain stages of development the archetypal image must, of course, be constellated by a human person does not do away with the problem.

For this reason Moore's "mining experiences" may perhaps have had a releasing and confirmative effect, but certainly not a "constitutive" one. Even without this outer experience he would still have achieved his specific work, just as with no practical experience of caves people today still dream about them and have

fantasies of mysterious descents to the underworld.

The second problem, concerning the Oedipus complex, hangs together with our answer to the first. There can be no doubt that the personal, masculine element is very much in abeyance in Moore's work, but this is naturally so whenever the creative individual belongs to a group in which the dominance of the matriarchal world is maintained. So far as the personalistic situation is concerned, here again we find all sorts of possible constellations, each of which lends itself to a construction of the Oedipus axiom in its own terms. If there is no father, then naturally the mother is overemphasized; if there is no mother, naturally the longing for the lost mother is overemphasized. A weak father causes the supremacy of the mother figure, while a strong father causes fear of himself and regression to the mother.

Only when it is recognized that man's psychic development depends on environmental influences only at certain critical periods of transition, like his physical development, but in general is directed by transpersonal factors known in analytical psychology as archetypes—only then will the false personalistic causality theory of psychoanalysis be superseded, and only then will there be an end to the often ridiculous search for biographical facts that are supposed to explain everything but in reality mean very little.

VI

WHILE the motif of the feminine takes on new dimensions in the shelter drawings, but is still realized mainly in the world of earthly forms, another sculptural trend had begun to be noticeable, as early as 1938, in the "stringed figures." With these Moore's work, reverting to the first period of abstraction, gradually reaches a new level of achievement in both form and content.

When discussing the sculptures and drawings that represent the *participation mystique* between mother and child, we showed how the dynamic currents of relationship are made tangible and visible in these figures, and how the structural masses are concretely related to one another through the strings and wires. It is understandable that more stress is laid as a rule on the formal character of this "invention" of Moore's than on the sense of depth conveyed by the crisscrossing currents of wire by which mass and space are related to one another in new perspectives. "The function of the string or wire is threefold. It contrasts, in its tautness, with the curvilinear contours of the mass. It establishes a barrier between the space enclosed by the sculpture's mass and the space which surrounds the sculpture only,

a barrier which, being a cage and not a wall, can contain the space on its open side while allowing it to remain visible. Above all, the string provokes movement of the spectator's eye along its length and thereby increases his awareness of the space within the sculpture —especially when . . . one set of strings can be seen through another, so creating a counterpoint of movement which brings to life the space around and within which the strings operate."[1]

By means of this technique Moore has succeeded in conveying a new and peculiar experience of space, especially when the figures are no longer naturalistic and only the pure play of abstract masses and forms is involved. Space, in relation to mass, begins to play an active and rather uncanny role. Consider the strange 40 "head," *String Figure No. 2*. Here there are no dynamic 23 currents of relationship as in the mother-child group already discussed. The strings, passing at different levels and in different directions "in front of" the actual sculpture, not only emphasize the depth dimension by cutting it up into layers but, together with the head looming up behind them, produce a peculiar world of relationships that are quite alien to us. By this extraordinarily simple plastic means the sculpture acquires a kind of ghostly animation that is extremely impressive. It and the drawings akin to it are beings with their own depth dimensions, and their inner dynamism, totally different from ours in its physical effects, has something daemonic about it.

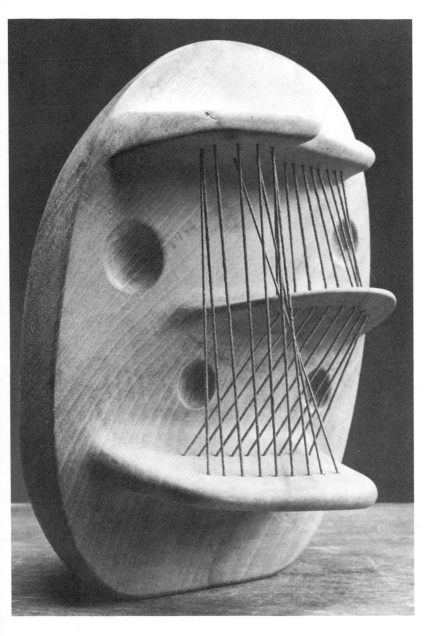

40. **HEAD: STRING FIGURE NO. 2**
Elmwood and string. 1938. H. 8″

41. FOUR FORMS. *Chalk and wash.*
1938. 11 × 15"

This strange, daemonic character becomes immediately apparent when we see the head standing beside three other "forms" against a shadowy landscape. The nonmaterial but living and autonomous quality is just as impressive in the three other "forms"; but whereas in them the feeling of strangeness predominates—for they seem like beings from another world—the head keeps its human likeness, converted, however, into something entirely spectral.

Here again we come upon an archetypal motif even in the form used, for in primitive carvings and paintings the spectral and daemonic is frequently represented

41

with the help of geometrical abstraction.[2] The motives underlying this formal principle will not be so hard to understand after all we have said in the foregoing. Owing to the polarization of spirit and body, "spirit" and also "the spirits" have to be represented as relatively bodiless and alien to the body. What we call "abstract" is simply a "spiritualization" of this sort, from which everything individual and physical has been stripped away.

Besides this abstract, alien, and autonomous quality, there is something else that connects the stringed figures with an important but quite different aspect of Moore's work, and that is the "mechanical" principle. The stringed figures belong in part to this world of quasi-mechanical structures whose interior dynamism is shown as a physical mechanism.

This principle can be seen very clearly in other drawings, where the inside of the body appears as an inner world of weird-looking machinery. Characteristically, these pictures are always of the female body as the mysterious "workshop of nature" in which life is secretly concocted. *e.g., 42*

This motif, too, belongs to the archetypal nucleus of the Primordial Feminine round which Moore's work revolves. The miracle of a woman being able to "make" life in her own body is the central miracle not only of the matriarchal world that is still alive in all of us, but of life itself. This miracle has always been regarded as

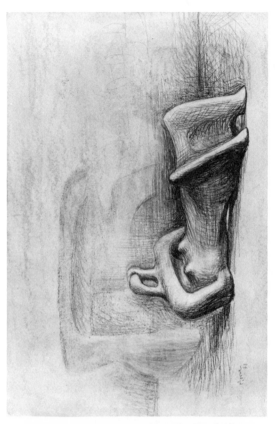

42. TWO STANDING FIGURES:
DRAWING FOR SCULPTURE COM-
BINING WOOD AND METAL
*Chalk and water color. 1940.
22 x 15"*

43. RECLINING FIGURE
Chalk, pen, and wash. 1938. 15 x 22"

being somehow akin to a mechanical process. In folk tales the child is "baked" or "cooked" in the oven, and the transforming cooking pot or caldron is a typical symbol of the womb in which the miracle of transformation takes place that results in a child. The mysterious retort is one of the central secrets of alchemy, and the transformative processes in retorts and furnaces, and in the *vas hermeticum*, which obviously derives from the mystery-making womb of woman, culminate in the "birth" of the stone, the *filius, filia*, king, or whatever the symbols of the end product of this natural-unnatural process of transformation may be called. Moore's specters and spooks inhabit an intermediate realm that is still part of nature and whose abstract mechanical forms belong rather to the "witch's kitchen" and its imitation of natural change than to the realm of technology.

The link with nature is not so obvious on this daemonic level, but is plain enough in the large reclining figures and in many of the other sculptures. The fact that, as Moore himself says, his sculptures belong "out of doors" has little to do with their artistic effect, with lighting or suchlike considerations. Their real and secret affinity with the landscape comes rather from the fact that, for Moore, they are truly alive—if not in quite the same way that human beings, animals, and plants are alive. His remarks about their center of gravity, their roundedness and completeness, cannot but tell us

that Moore, possibly unconsciously, brings living things to birth like a "master workman" of the Great Mother, her masculine counterpart, shaping them or letting them shape themselves.

Thus the reclining figures are mostly of the Earth Goddess herself, realizations of her divine presence. Hence, in the drawings, we almost invariably find her strange incarnations lying in a landscape. These drawings give one the feeling that inhabitants of other worlds have strayed into our world, or rather that invisible beings who were always present without our knowing it have sprung up like apparitions and been solidified by Moore. The fact that we know he has "made" them does not diminish the effect they have on us. The novel and unique thing about these "materializations from the inside" is that they are all organically connected with the life of the earth, unlike, for instance, those loathsome photographs of ectoplasmic materializations at séances. Moore the "spirit seer" glimpses his transpersonal figures in their own world, but this world is ours too.

For this reason one should not really speak of "materializations from the inside" or of "psychic projection." The essence of these figures lies in their earthliness and naturalness; they are not inner psychic images seen in a vision and then transplanted outside, but actual parts of the unitary world, deities whose objective existence and kinship with the earth are just as evident as Pan in

e.g., 43

his rustic setting was for the Greeks. It is the natural-
ness of these strange and, in a sense, improbable figures
that makes them so striking. Their relation to nature is
so indisputable, their form so nearly natural, so very
like what nature would produce, that they seem to be a
newly evolved species of human being. They are cer-
tainly no more improbable than an elephant would be
for a man who had never seen one, and the fact that
they deviate from the human shape in certain particu-
lars but resemble it in others is a feature they have in
common with a number of other creatures that actually
exist. At any rate they are no more unnatural than cen-
taurs, nixies, satyrs, and elves. All these figures would
be most inadequately understood if they were de-
scribed as mere projections of psychic contents into the
outside world, for they are close to nature and reality in
a profound sense and are not just psychic formations.
Rather, they are approximations to the unitary reality
that existed before the split into inside and outside, in
exactly the sense formulated by Goethe:

> *Nature has neither core nor skin,*
> *She's both at once, outside and in!* [3]

To speak of the "nightmare quality" [4] of Moore's colors
is legitimate only insofar as they are the colors of "an-
other world," but not a world of fear and horror. Since
we cannot include any color reproductions in this book,
there is little point in going more deeply into the ques-
tion of his color qualities. Undoubtedly they belong to

44. IDEAS FOR SCULPTURE
 Chalk and wash. 1938. 15 x 22"

a "dream world," but this designation would only be correct if we understood it as a realm that, while it cannot be experienced by the normal ego consciousness, is not to be localized in the unconscious psyche. Once again, it is a question of an intermediate realm not yet polarized into opposites.

The emphasis on the organic as opposed to the geometric structure of the figures, and the fact that the landscapes with their colored background of boulders and rocks appear as ingredients of our ordinary reality despite their affinities with an inner world, mitigate the

45. IDEAS FOR SCULPTURE
Chalk and wash. 1938. 15 × 22″

"spectral" character we have spoken of and—at least in
the case of the larger figures—bring out their "numi-
nous" quality.

It is different with those of the stringed figures which
stand in a "setting" of bare walls so typical of Moore's
drawings, with bleakly geometrical window openings 44, 45
placed high up in a strange rhythm of squares, rectan-
gles, and oblongs of various sizes. The placing of the
Ideas for Sculpture in a "setting" animates these mys-
terious beings to an extraordinary degree and makes
them even more uncanny. The setting—which, as in

many other of Moore's drawings, is peopled by women
—forms a direct contrast to the "natural" habitat of the
large figures, and may therefore be taken as a symbol of
our civilization, of our urban, walled-in existence, and
of the restrictedness of our consciousness, which has
lost touch with nature and life. It is a prison life that
the settings show us, and our estrangement from na- 46
ture, our imprisonment in a world of walls, is revealed
in the eerie loneliness that surrounds each of the figures
trapped in this terrifying milieu.

This loneliness of the individual, which is an essential
mark of modern man's suffering, has led other artists—
Giacometti, for instance—to sculptural variations on
the theme of spiritual isolation, where man is reduced
to a ghostly thread of energy vibrating in an empty uni-
verse. With Moore, however, the individual as such has
never become a subject for sculpture. He fashions only
symbols of gods and demons, of collective situations
and psychic states.

The haunted bleakness of Moore's prisonlike rooms is
certainly no less enigmatic than Chirico's endless vistas
of streets and squares.[5] The window openings, set high 47
up in the walls, lead nowhere, they enhance the feeling
of being shut up in a cell, and seen from outside, on a
street wall, they suggest some hermetically sealed mys-
tery. And always the rectangles and oblongs follow a
peculiar rhythm of their own, as though to mute music.
Often there seems to be a secret connection between

them and the forlorn figures in the room, but it is blurred and indecipherable, like words in a dream language. One feels that the window slits are pointers to some powerful and incomprehensible reality in the background, which, as in the works of Kafka, has its own horizon far beyond the stage reality of this prison world, and an amplitude that remains forever inaccessible to human consciousness.

The affinity with Chirico, in whose early paintings the reclining figure in the middle of a public square likewise plays a large role, is obvious enough—it is as though both artists were reporting on strange travels to different parts of the same country. But whereas in Chirico the arcades and houses, rising starkly above the empty streets and squares, recede into infinity, the figures and groups in Moore's drawings stand about in barren cells and enclosed yards that are infinitely far removed from the spaciousness of Chirico's landscapes. The eerie quality of Chirico comes from the unending openness that lies over everything and, like a cold wind from outer space, freezes the breath of life. Moore's claustrophobic settings are the exact opposite of this— they are expressive of a cramped existence that is cut off from the forces of nature and can only breathe artificially, as if with the help of oxygen masks. Only when this stifling atmosphere was burst asunder by the fearful catastrophe of the war were new possibilities opened to Western civilization and also to Moore's work. Only

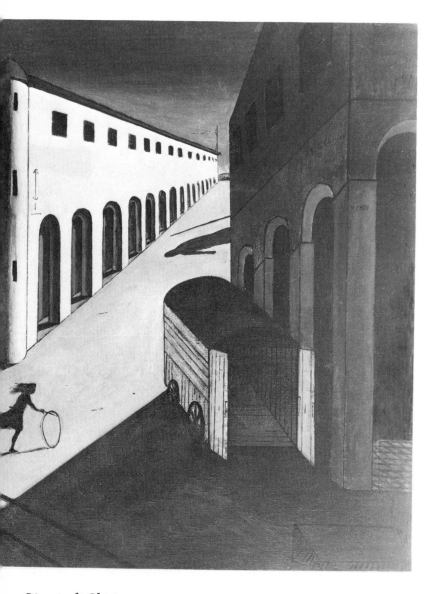

47. Giorgio di Chirico. MELAN-
CHOLY AND MYSTERY OF A
STREET. *Oil. 1914. 34⅜ × 28⅛″*

48. FIGURES IN A SETTING
Chalk and water color. 1948.
19 × 24½″

then, after changes and developments to be discussed later, did these compulsive and threateningly bare prison walls roll back to reveal the world with its wide horizons.[6]

Despite the importance of simplification in Moore's artistic development, it should not be forgotten that the principle of "opening out" brought with it an extraordinary enrichment and complication of sculptural forms. About the year 1940, shortly after the outbreak of the second World War, a crucial modification of this "opening out" becomes apparent. Until then the holes

48

and cavities in the reclining figures had progressively eaten away at the sculpture's mass; but despite increasing emphasis on their transpersonality, the earthy character of the figures, the predominance in them of the organic and fruitlike, had been preserved. With the stringed figures made just before the war, however, space began to become independent. Mass and sculptural density gave way before a veritable "storm of the spirit" that eats into the solidity of the sculptures more than ever. The trend toward abstraction becomes "spectral" and takes a sinister turn. Just as the stringed figures show the earth as an abode of daemonisms, so the known things of everyday become a façade for something unknown and mysterious. The ghostliness that characterizes the latest phase of Moore's work hangs together, in our view, with his experience of war and death. It is as if the feminine archetype had appeared, during and after the war, in a new manifestation, which does not, however, find expression only in increasingly "abstract" ghostly figures. She now appears as a spectral death goddess; that is to say, she no longer shows only her good and nourishing side, the fertility aspect, but reveals her negative, devouring, sinister, and cruel character.

We have already pointed out, in connection with the shelter drawings, how nearly the recumbent sleepers are like the dead, and how the protection afforded by the swathing blanket is often barely distinguishable

37

49. WOMAN SEATED IN THE UNDER-
GROUND. *Pen and water color.*
1941. 22 × 15″

from the final security of death. Some of the shelter drawings are not just pictures of underground caves, but of the underworld, and the livid somberness surrounding the figures is that of a genuine inferno. The spectral aspect of the feminine archetype that everywhere makes it assume the frightening form of the hag, revenant, and devouring mother appears—like everything else Moore does—as an absolutely new figure in our age. Whereas death, hitherto depicted in European culture as a skeleton doing the death dance, or as a warrior, murderer, or man with a scythe, has always preserved its masculine character, Moore's death figure is feminine—she is the Great Goddess manifesting herself as mistress of death. 36 49

In the formidable *Reclining Figure* from late 1939, everything fruitlike has been melted away from the woman's body, and its deathly machinelike character is very much to the fore. The reduction to pure line and the evaporation of mass into empty space go far beyond anything suggested in the earlier drawings. 50

Two manifestations of the Great Goddess now begin to appear side by side and in opposition to one another. As guardian and protectress, she is the tutelary deity of the shelters, offering refuge and safety. She is goddess of earth and of the caverns under the earth, of the transpersonal womb, of security and sleep, to whom all things mortal and conscious can flee. And as little as the sinking of day into night and of consciousness into sleep

50. RECLINING FIGURE
Lead. Late 1939. L. *13"*

is a morbid phenomenon of regression, but a natural datum of human existence, so flight to the shelter of the mother cannot be regarded as negative or infantile.

Alongside this "good" goddess, the positive side of the archetype, there stands the other, and the inherent duality and ambiguity of every archetype sets up in Moore the almost dangerous tension characteristic of his work at this period. The sheltering mother of night and sleep is also the deathly mother of graves and the underworld, of war and the bombed buildings. While *49* her positive character is bound up with the symbol of the swathing garment or blanket, its deadly and de- *38* structive opposite finds expression in the naked skeleton, stripped of all organic fullness and reduced to a spectral machine. The supreme example of this representation of the death goddess is the above-mentioned figure from late 1939. *50*

VII

IN SEEKING to understand the irrational, subterranean laws of the creative process, we should beware of simplifying the richness of Moore's work by laying too much stress on straight-line developments. Not only is it one of the attractions of our task to follow out the winding path of creative development in a great artist, but this procedure is also important psychologically if we wish to gain a deeper insight into what we have called the "matriarchal" process of creation that is so typical of Moore.

The seemingly inexplicable arbitrariness with which new motifs suddenly appear, only to be set aside for a while and then later taken up once again and developed further, proves to be an inner necessity in the life of creative individuals; for the play of dialectical tensions leads to their resolution in an "irrational third," which in its turn becomes the starting point for new tensions, developments, and artistic solutions. Unlike the straightforwardness of conscious, scientific thinking that strives toward a goal, the creative process follows the natural, unconscious laws of growth, which the conscious mind of the artist obeys. When we seek to under-

stand this growth, we find that a germinally homogeneous disposition unfolds into a plurality of creative differentiations, expanding like the crown of a tree into a complex system of branches, each one following its own law of growth, which yet in their totality reveal the unity and harmony of creative existence.

It was in the years immediately following the war that Moore's work started to grow beyond the two big themes round which it had always revolved. And although these themes remained central, his sculpture was complicated and enriched by the gradual emergence of new forms and contents. The polarizing of the Great Goddess into a positive guardian on the one hand and a devouring phantom on the other undergoes new elaborations in his later work, but it no longer remains caught in these opposites and in the inner tensions they generate. Already in the wartime shelter drawings, and more clearly still in the first years after the war, we can see a new and third thing rising out of the creative unconscious and transcending the tension of opposites in exactly the way Jung has described when he speaks of the appearance of the transcendent function, the "redeeming third." [1] In the livid underworld of the shelters, haunted by death and ghosts, there develops, almost imperceptibly at first, but gradually growing stronger, a new and positive manifestation of the feminine. It no longer appears as a single figure, but as a plurality, and finally as that archetypal triad in which,

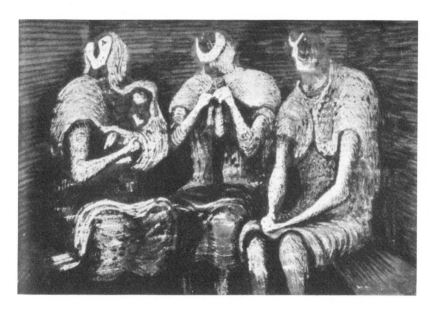

51. THREE FATES.
Chalk and water color.
1941. 15 x 22"

from the beginnings of history, the female deity has re-
vealed herself in her special form as the goddess of fate
—Norns, Moirai, Parcae, etc. The deathly, under-
world atmosphere of the shelter scenes reaches its peak
when the apparently prosaic and harmless figures of
women are seen under their infernal aspect. The
women in these drawings are often gruesome and un-
canny, but in some of them they have taken on non-
human or extrahuman proportions. They are no longer
inhabitants of London but emissaries of suprapersonal
powers. That this is not just a subjective impression, but

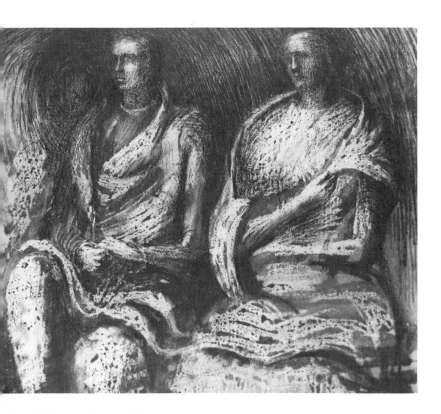

52. SHELTER SCENE: TWO
SEATED FIGURES.
Chalk, pen, and wash.
1940. 17 × 20″

corresponds to the image Moore himself had in mind, is evident from the 1941 shelter drawing of three

51 women with a child, which is called *Three Fates*. These fate women will receive their definitive form later in Moore's work. In the drawing, the preliminary form of this final manifestation of the Great Goddess is still dominated by the impression of lividity and horror.

In direct contrast to this are drawings where the feminine archetype manifests itself in a world of superhumanly real forms and figures. Unlike the human creatures who seem almost entirely divested of materiality, the figures of this world have a majestic stature and a coloring whose solemn tones enhance their human dignity. These beings no longer sit about in the underground stations of London; they are enthroned with

52, 38 strange finality amid the archaic drapery of their shawls and blankets. The garment that wraps them

37, 49, round or covers them has become not the winding sheet

33 of death, as in the pictures of sleepers, but a royal mantle. Sometimes, indeed, it seems as if the robe was

38 itself an independent entity, a sort of sheltering deity that gave the human beings nestling within it not only

52 protection and safety, but dignity and grandeur.

This emphasis on the human, which proves to be the center created by the tension of upper and lower forces, is altogether new in Moore's work and manifests itself in two ways: first in the pronounced "naturalism" of his forms at this period, and second in the development of

a new motif, the "family group," in which for the first time the man and father appears as the third figure along with the mother and child.

As early as 1934 Moore had written: "Abstract qualities of design are essential to the value of a work, but to me of equal importance is the psychological human element," [2] but it was only in 1944 that this human element became a central theme of his work. In numerous drawings and sculptures of the family group, the triad of woman, child, and man appears as the nucleus of everything human, with the man holding a position of importance. It is as though the transpersonal matriarchal world of the Great Mother were now superseded by the family, in which the man too has his place. The maquettes, statues, and drawings from the years 1944–49 bring a wealth of variations on the family motif. In all these groups a union of the personal with the transpersonal and universal has been realized, expressing the stability of the eternally human in the midst of fate.

34, 53, 54

Undoubtedly the "personal" fact that a daughter was born to Moore in 1946, after seventeen years of marriage, made an impression on him, and a personalistic interpretation would derive his development of the family group from this event. But in this case the falseness of such a thesis can be demonstrated. The first family groups start to appear in 1944, others follow in 1945, and the birth of the daughter crowns and confirms in an enigmatic but appropriate manner Moore's

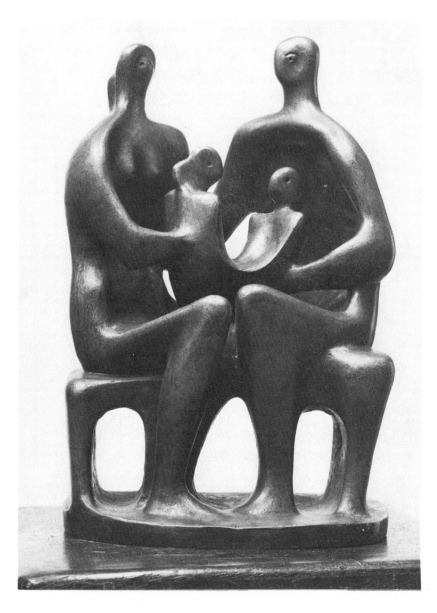

53. FAMILY GROUP
Bronze. 1947. H. 16"

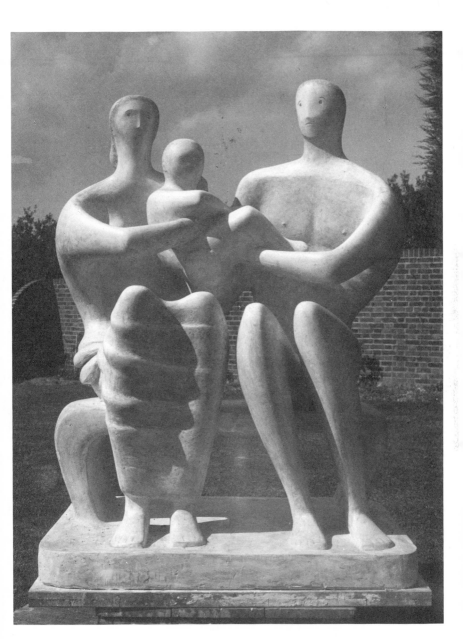

54. FAMILY GROUP. *Bronze. 1945 and 1949.* H. 60″

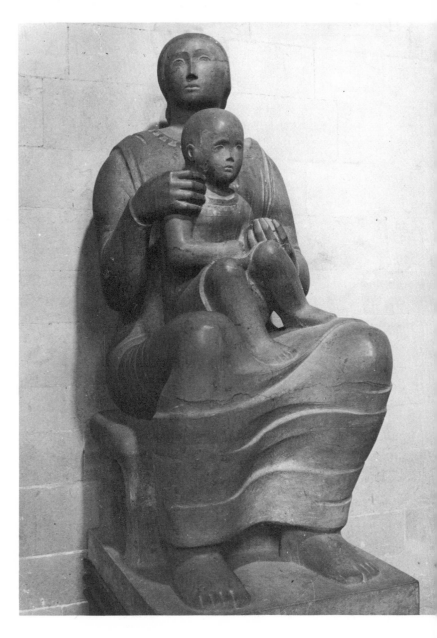

55. MADONNA AND CHILD. *Hornton stone.* 1943/44. H. 59"

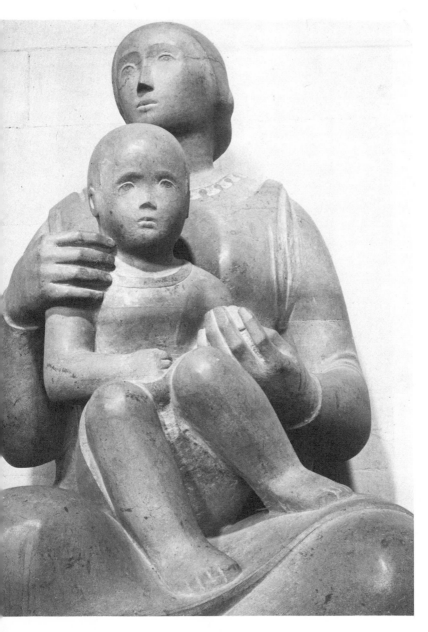

56. DETAIL OF 55

57. MAQUETTE FOR MADONNA AND CHILD.
 Terra cotta. 1943. H. 7¼″

new motif, which then takes a back place after 1946.

Besides the motif of the family group as the nucleus of human life and the confirmation of man himself as the focus of all constellations of transpersonal forces, a "classic naturalism" that represents a further strengthening of the human element is also apparent at this period. The mother-child motif reaches its sublimest expression in the 1943/44 *Madonna and Child* for the Church of St. Matthew, Northampton. This *Madonna* and the *Memorial Figure* of 1945/46 are masterpieces in the naturalistic, representational style that has become increasingly characteristic of a new tendency in Moore. The superb simplicity with which the Madonna sits there, as though for eternity, realizes Moore's express intention: "I have tried to give a sense of complete ease and repose, as though the Madonna could stay in that position for ever (as, being in stone, she will have to do)." [3] She has the "quiet simplicity and sublime grandeur" that have been falsely ascribed to classical antiquity. And the way the child (whose head is so puzzlingly like Moore's own) gazes into the world is strangely moving.[4] Nevertheless, this Madonna figure and other sketches of the kind seem to lack that drastic contemporary element that makes their eternity *our* eternity. This does not detract from the beauty of these sculptures so much as from their "aliveness," which is otherwise the most revolutionary quality of Moore's work. His "classic naturalism" harks back to motifs that

55, 56

Frontis., 101

e.g., 57

first appeared, as we have shown, in the "draped figures" of the shelter drawings.

With the end of the war and the need to discover a new life synthesis, a flood of new creations at last begins to overcome the bipolarity of the mother-and-child and reclining-figure motifs. One of the finest manifestations of this world of the feminine is a drawing from the year 1946, *Standing Figures with Rock Background*, which is done with a new naturalistic-classical intensity. (By "naturalistic" I mean only similarity to nature, which in these drawings appears as sublime and ideal rather than "realistic.") Characteristically, this divine-human world is no heavenly Olympus, but a world of earth and of the interior of the earth. The development of the earlier draped figures to these superhuman proportions is typical of Moore's creative manner of working—he never gets stuck in a formal motif. He does not rest content until he has penetrated to the transpersonal core that unconsciously moved him from the beginning, when it first became visible in the new formal motif of the draperies, finally crystallizing out in the figure of the fate goddess.

At this point the necessary inner dialectic of the creative process, with its unconscious enantiodromia, becomes apparent. That is to say, the "third" line of development, tending in the direction of the fate goddess and emphasizing the human element, cannot assert itself in a direct and straightforward manner. Before it

58. RECLINING FIGURE. *Bronze. 1945.* L. *16"*

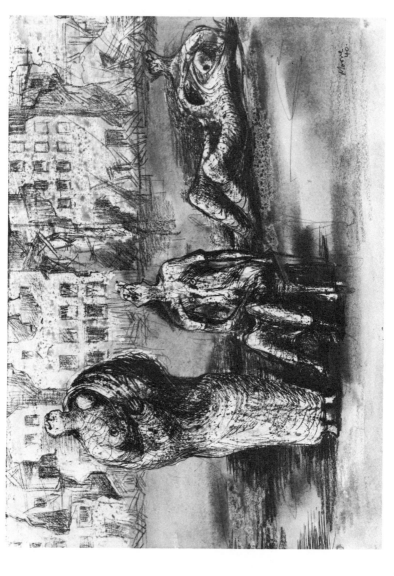

59. STANDING, SEATED, AND RECLINING FIGURES AGAINST A BACKGROUND OF BOMBED BUILDINGS

can reach its highest expression as the "reconciling" and "mediating" function, the negative aspect of the feminine archetype appears once more, with a crassness and savageness that far exceed anything yet accomplished in Moore's work. There is no doubt that the experience of war and death made a profound impression on Moore as an artist. Only after enduring and conquering this most frightful catastrophe by giving it visible shape could he find deliverance through the uniting symbol of the fate goddess.

In the marvelous but horrific figure from the year 1945, the empty curves and flattened planes have completely deprived the body of its sheltering, fruitful, cavelike character. It is still feminine, the hollow eyes are reflected in the sunken nipples, but its incorporeality is utterly negative. Although the sweeping lines of the figure are still organic and not geometric, there is nothing here of earth and landscape. It is all emptiness and air, and its contours have the effect of façades behind which Nothing crouches. This figure is the supreme and final epitome of what was first hinted at in the 1940 drawing of *Standing, Seated, and Reclining Figures against Background of Bombed Buildings.* The mistress of all bombed buildings lies here before us, as Goethe says, "mysterious in the open light of day." While, true to the law of the material, she takes this form in bronze, her incarnation in the softer, more rounded contours of clay is different but no less un-

58

59

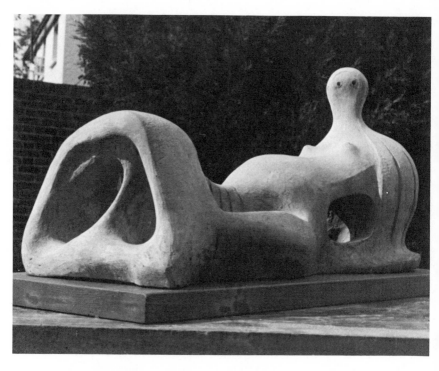

60. RECLINING FIGURE
Terra cotta. 1946. L. 17"

60 equivocal. The terra cotta from 1946, with its darkly
staring eyes and mouthless head, is a goddess of graves.
She too is a cavern, and it would be in keeping with her
nature if coffins and corpses were fed into that sinister
oven, to be consumed or baked into new life. For the
mystery of the Great Mother in her death aspect has al-
ways been that her deadly womb is at the same time
the womb of rebirth. Once again Moore has depicted
the Great Mother in one of her archetypal forms, as the
embracing and all-containing void.

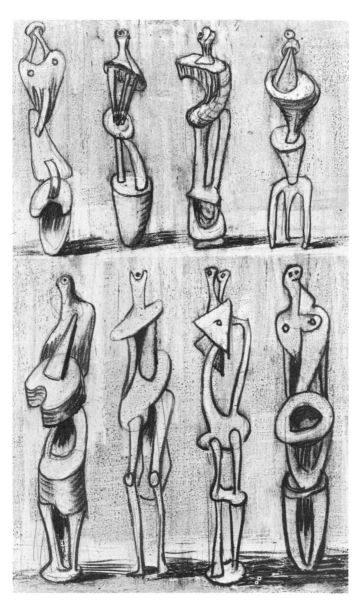

61. STANDING FIGURES: IDEAS FOR METAL SCULPTURE.
DETAIL *Chalk and water color. 1948. 11½ × 9½"*

If these figures show her as a death goddess, her witchlike, spectral qualities appear for the last time in the drawings dated 1948–50. Here the earth and death goddess is rising up in wrath—a goddess of the atom bomb, of the terrible destructive power of matter, which is at the same time the phantasmal power of destruction lurking in the human psyche. Everything that makes for organic synthesis and growth, development and life, is mocked and denied in a grotesque and almost insane way. This extreme and most frightful manifestation of the Great Goddess may possibly be connected with the despair that seized Western man when he realized that the second World War and the conquest of Nazism with so much sacrifice had not brought peace, but that the will for destruction is a fundamental expression of humanity in our dark and violent age.

The motif of the "Fate Goddesses" begins with the draped figures of the shelter drawings and the later groups of women "in a setting," sometimes winding wool like the Norns, sometimes with a child. Often there are three women, who appear to be casting the fate of the child like the three Moirai or the three fairies. This archetypal motif culminates in the *Three Standing Figures*. These, in their simplicity and mysterious monumentality, are the most magnificent portrayal of the Fate Goddesses yet known to sculpture. The simplification of "abstraction" combined with humanist "naturalism" forms a synthesis that only became

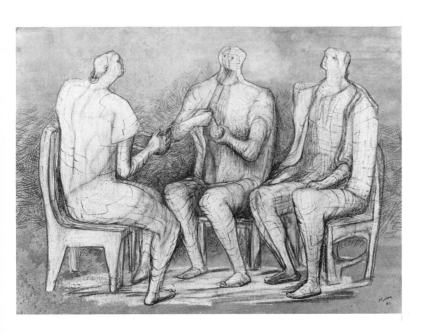

62. WOMEN WINDING WOOL
 Chalk and pen. 1942. 16 × 20"

possible after all aspects of the feminine archetype had
been experienced. This is no longer only the birth-giving,
sheltering Mother and Earth Goddess, nor only the
gruesome goddess of death and the grave. Here the
spiritual core of the feminine archetype has been 65
reached and shaped in stone, a numinous center that
stands, solid and unshakable, on the earth and amidst
its trees, and yet is inaccessibly strange, infinitely sur-
passing and looking beyond this world. For all their
rootedness in earth and their human shape, the figures
are turned entirely elsewhere; their gaze is directed into
the far distance, augurs of some "supercelestial place"

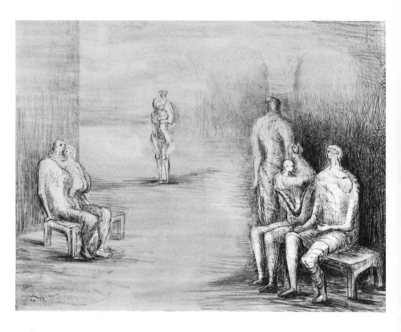

63. FIGURES IN A SETTING
Pen and water color. 1942. 16 x 21"

with whose observation they seem to be entrusted. They
have the rocklike dependability of the Great Mother,
but their steadfastness includes death and disaster as
well as life and its duration. The bond between the
three figures as they gaze so intently into the future is so
strong that despite their individual differences they
have the effect of a unity. In them life and death are
transcended, and out of these opposites they produce a
third which—be it called Fate or Meaning—arises from
the interplay of black and white, life and death, past
and future, as a fulfillment of the present, a higher real-
ity of being.

64. THREE STANDING FIGURES. *Darley Dale stone.* 1947/48. H. 84"

65. DETAIL OF 64

Besides giving shape to these great archetypal fig-
ures, Moore has consciously understood their psy-
chological and human significance: "There are uni-
versal shapes to which everybody is subconsciously
conditioned and to which they can respond if their con-
scious control does not shut them off." [5] Experiencing
mankind as a collectivity during the war, he saw how
horror of the void drove them to seek shelter in the
depths of the Earth Mother, and he gave visible and
godlike form to the collective forces of annihilation that
threaten the living. He also saw that art is the assertion

and manifestation of the universally human, and that experience of this is the first step toward the conscious realization of a unitary culture beyond race, nation, and time. He has glimpsed the oneness of the creative transpersonal powers in humanity itself when he says: "But underlying these individual characteristics . . . a common world-language of form is apparent in them all; through the working of instinctive sculptural sensibility, the same shapes and form relationships are used to express similar ideas at widely different places and periods in history, so that the same form-vision may be seen in a Negro and a Viking carving, a Cycladic stone figure and a Nukuoro wooden statuette." [6]

With this breakthrough to a standpoint that embraces the whole of human culture and the transpersonal powers working within it, Moore at last succeeded in throwing off the time-bound feeling of incarceration and isolation that characterized his haunted "settings." The clearest and most startling expression of this breakthrough is the drawing already mentioned. The bonds have burst, the prison has *48* opened, and there, where the walls have rolled back, stand the three Fates. But the infinitude they gaze upon is the boundless horizon of the sea, which, in vivid contrast to the cultural confinement symbolized by the walls, has always and everywhere been the symbol of the creative unconscious from which new life springs.

VIII

THE formulation of older motifs does not cease even when new contents appear in Moore's work. Thus, simultaneously with the fate goddesses and family groups, we find new variations of the reclining-figure and the mother-and-child idea. But after the final por-

64–65 trayal of the *Three Standing Figures,* some quite new motifs appear, of which the one that comes most strongly to the forefront has definite connections with Moore's central problem.

The motif that first began to assert itself in all sorts of surprising variations about 1948 is the modeling of the head as an independent structure. During the process of simplification and denaturalization the head, as part of the whole figure, was originally reduced to a knob-like, spherical form with hardly any plastic significance. As the symbol of individuality, it had no more importance in sculptures whose emphasis fell increasingly on their transpersonality.

Already in 1931 we find the head reduced to a protu-
e.g., 10 berance marked with a circular symbol standing for the eye and mouth. In the period of abstraction this circu-
16 lar symbol appears as a hole, the first symptom of pene-

tration into the head, whose volume, like that of the breast, can be conceived as either a sphere or an orifice. Dot, knob, circle, hole, eye, mouth cavity, as symbols for the whole head, lead finally to curious formations like the split head or, later, the "saddle" head with a 50, 51, 77 sphere in it.[1] These head forms are nothing but appurtenances of the body. Formal correspondences—the knees and the breasts, for instance—often reflect the formation of the head in Moore's work; thus the two knees and breasts reflect the doubling of the head in a reclining figure drawn in 1938, and in a 1939 sketch the 43 head is even tripled.

These reduced head forms give the figures a somewhat uncanny look, since the head and face express all that is most human in a person, and their absence makes him altogether inhuman. The exact opposite of this reduction, namely, the process that culminates in an equally uncanny super-autonomy of the head, is a development connected with the principle of "opening out" and with the transformation of the body into a cavity.

The conception of the body as a magical vessel, a transformative retort that is at the same time a mysterious cavern and a landscape, gradually brings about a strange transformation of the head, as though it too had been affected by the symbol of the body cavity. The head itself becomes the sheltering uterus. The future motif can already be seen in the heads drawn in 1944, 66

66. HEADS: IDEAS FOR METAL SCULP-
TURE. *Chalk, pen, and water color.*
1944. 18¾ x 16"

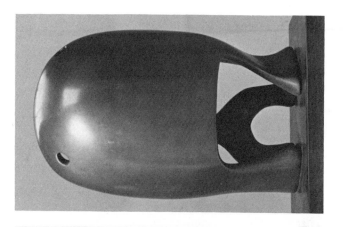

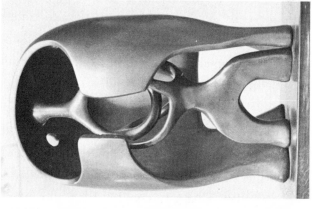

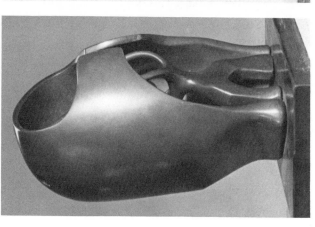

67*a–c*. THE HELMET. *Lead. 1939/40.* H. 11½"

though this series of nine heads is only a tentative experiment. The feeling of uncanniness predominates, the forms grope toward a final solution, all the possibilities—especially in regard to the eyes—are tried out, but the head cavity as such does not yet play the decisive role. This is all the more surprising in that the final form—that of the "helmet"—had been found as early as 1939, but then had to wait ten years until it was developed further.

67a–c This first *Helmet* from 1939/40 is still dominated by the mother-child symbolism: it forms the uterine shell within which there dwells a child inhabitant. Although the shell has an opening to see through, there is nothing except the name to suggest a working out of the head motif.

72 Ten years later, in 1950, Moore arrives at a very different artistic solution of the problem, though it still remains part of the total problem that had dominated his work up till then. That is to say, it is a logical continuation of the fundamental problem of "inside" and "outside," which, as we have tried to show, again and again finds entirely new artistic and sculptural solutions. This

68 problem, illustrated in the *Page from a Sketchbook*, is finally worked out in the "head sculptures."

69, 70 The *Openwork Head* and the *Head*, both from the exceedingly fruitful year 1950, are examples of one way in which it can be solved, the head being conceived only as a mask, a hollow shell derived from the outer

68. PAGE FROM A SKETCHBOOK
Chalk, pen, and water color. 1948.
11½ × 9½"

layer of skin and muscle. These heads have been, so to speak, peeled off the bone, the density and solidity of the head's structure are broken down, and all that remains is the outline of the form, with nothing inside save the air filtering in through the openwork. Although both these sculptures are of bronze, they have the lightness of sketches, and this is emphasized still more by the fact that all other parts except the masklike face are made of strips of metal, set so far apart that they never form a continuous surface. In contrast to the massively uniform structure of the head as a vessel, the filigree work of the "openwork heads" is completely empty. The formal experiment has resulted in a representation of the "nihilistic" man of today, obsessed with the Void, *le néant*, nothingness.

Doubtless the hollow "outward" form of these heads, so far as Moore was conscious of it, is simply the product of a formal experiment. Nothing is further from us than to suggest that Moore has any idea of the "meaning" we find in them. All the same, it lies in the nature of the creative individual to express through his work the purposive tensions of his and the collective's unconscious independently of the rationalizations of the conscious mind, even though the psychic dimension seeking expression through him may make use of conscious motivations.

The "openwork heads" are forerunners of the two "helmets" done in the same year. Although it is rather

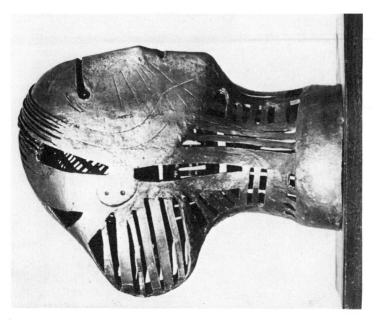

70. HEAD
Bronze. 1950. H. 15½"

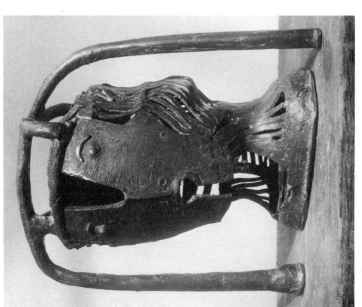

69. OPENWORK HEAD
Bronze. 1950. H. 7"

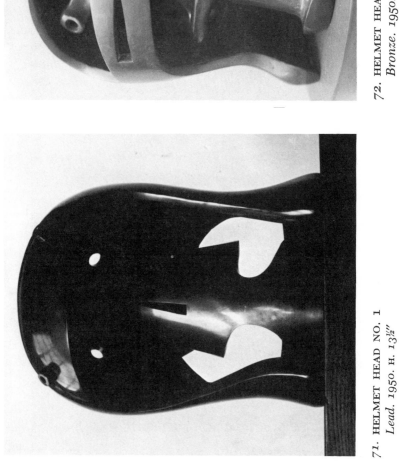

71. HELMET HEAD NO. 1
Lead. 1950. H. 13½"

72. HELMET HEAD NO. 2
Bronze. 1950. H. 14"

difficult to see in the illustration, *Helmet Head No. 1* 71
(1950) contains, just as *Helmet Head No. 2* does, an in- 72
terior figure, which together with the casing builds up
the total effect. The uterine vessel of the 1940 helmet is
now more like a head with raised visor, the semblance 71
of a human face being produced by the interior figure
and the eyeholes in the casing. The motif of the diving
helmet, the crash helmet, and the gas mask, all of which
convert the human face into something strange and in-
human, has here been wrought into a new and sinister
form of death's-head. What the skull symbolized for
our forefathers with its human-inhuman face, stripped
of everything organic and individual, which forever re-
mains and yet is a reminder of mortality—for this natu-
ral symbol of death there is substituted the contempo-
rary unnaturalness of a purely technological death. The
inhuman ruthlessness of technological science and of
the warfare that is its identical twin stares out of this
helmet with everlasting, metallic indifference. And in-
deed war and disaster as manifestations of technologi-
cal death are much more closely connected with the
anxiety of modern man than is the danger of "natural"
death. It is almost a wishful fantasy if he wants to be
allowed to die peacefully in bed instead of being cut
to pieces by shell splinters, buried under collapsing
houses, roasted alive by atom bombs, or reduced to a
mass of suppuration by radioactive fallout. What makes
this death's-head so horribly sinister is that the human

form of the face is still preserved, though even more remotely than in the skull. It arouses in us the same horror we feel for beings from unknown worlds, who have nothing in common with the organic life of our earth. All earthly organisms have a common origin and common childhood in relation to the Great Mother of All Living. But we have no relation at all to the alien, technological world of the inorganic that confronts us in this helmet with its deathly stare.

72 *Helmet Head No. 2*, for all its strangeness, is definitely a "head." The polarity and unity of this structure come from the balanced contrast between the outer form as the container and the inner form contained within it. As in the 1940 helmet, the head is like a maternal uterus with an embryonic creature inside. An interior being, having by nature a curious independence, as we shall see, gazes outward through the windows of the body casing. What we spoke of earlier as the archetypal constellation of a soul dwelling "in" the body is here concretized in a new way, and the common human experience that in a person's face there is an inner being looking out through the eyes of the body has become plastic reality.[2] This helmet is a simplified form of the openwork heads, but instead of being empty it is inhabited by the inner "soul child."

73 These inner beings, if one surveys Moore's development as a whole, prove to be little totalities, complete soul figures. This is obvious enough when we remember

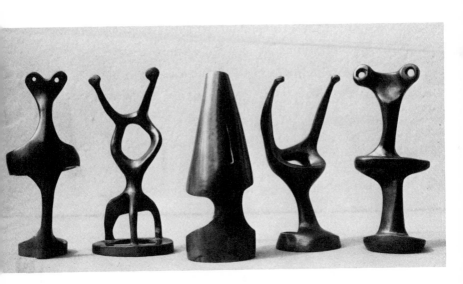

73. FIVE FIGURES: INTERIORS FOR LEAD HELMETS.
 Lead. 1950. H. C. 5"

that for many years the head often had a double form
in his sculptures. The bipolar top of the interior figure,
which stares out here like a pair of eyes from inside 72
the helmet, has long been for Moore a typical symbol
for the whole head.[3] This means that the little figures 43, 61
peering out of the head like souls are really little "men"
or "persons," an archaic idea [4] that is still preserved in
speech, for the "pupil" of the eye (*pupilla, pupula*)
originally meant a baby girl or doll. The living but in-
visible dweller within is made visible as the interior life
of the shell, its animating principle. What gives this
head its frightening and spectral appearance, however, 72
is not its novel form but the stark, staring terror of the
soul as it looks out of its rigid encasement. This terrified

and terrifying expression is heightened by the motif of "imprisonment," which we met earlier in another form. The figure in the helmet seems to be gazing not so much out of a window as out of the window of a prison.

That these child interiors really do signify something psychic when they are connected with the body, but become spectral or "spiritlike" as soon as they step outside it, is clear from the subsequent development of Moore's work. We come here to a strange overlapping of formal motifs that demonstrates this difference in a surprising way. When tracing the development of the female figures, we saw how the continual process of abstraction, in the sense of a disembodiment, finally resulted in spectral, witchlike figures. We now have the reverse process, where the "interior" makes itself independent of the body within which it was housed like a child. Both processes lead to very similar, indeed, almost identical forms; but both, if one interprets these forms in terms of their content, have an almost identical significance, since they represent something disembodied and in the nature of a spirit. This can appear, negatively, as a specter, or it can take on a positive and more exalted form, as if spiritualized into an angel figure.

74, 75 In the *Standing Figure* of 1950 and the *Double Standing Figure* of the same year, the figure that was inside the helmet has stepped outside and become over-lifesize. They bear only a very distant resemblance to

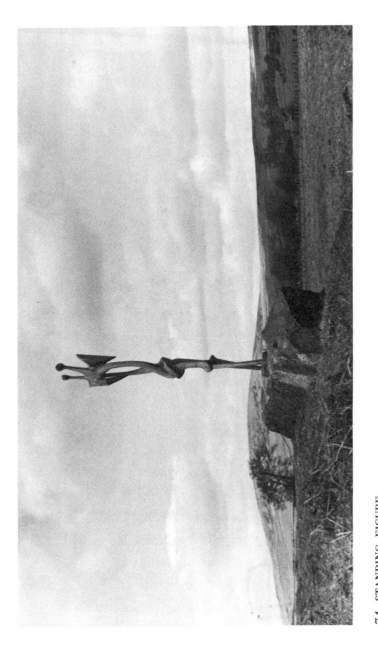

74. STANDING FIGURE
Bronze. 1950. H. 87"

the human form. What we see before us are beings who, when we remember the development of the head in Moore's other sculptures, seem to be two-headed. No doubt the formal motif of duplication and correspondence plays its part in the structure of these extraordinary beings, who look like a cross between the organic and the supernatural. But what does that tell us? What do any purely formal considerations tell us, when the main impression these beings produce is quite different, harmonious, and entirely new? When we see the wonderful figure standing alone in the Scottish landscape, the unique quality of these strange bronzes strikes us at once. For all its bizarre shape, no one can deny that it combines grace with monumentality. Like an enlargement of the little soul figure in the body, this supernatural being stands there keeping watch over the moors. Although a part of nature, it belongs to an order of being psychically and spiritually different from anything we know. Human, inhuman, and superhuman at once, it seems to us one of the strangest and most perfect representations of an angel ever to have been realized by a modern man and artist. But this figure, which seems to us an angel also because it is spiritual rather than spectral, sublime and more than merely daemonic, belongs, like the three Fates, not to heaven but to earth.[5] They are spiritual beings related to the earth— almost it seems as if they were destined to protect the earth from perils and catastrophes that approach it from outside, from above, out of cosmic space.

74

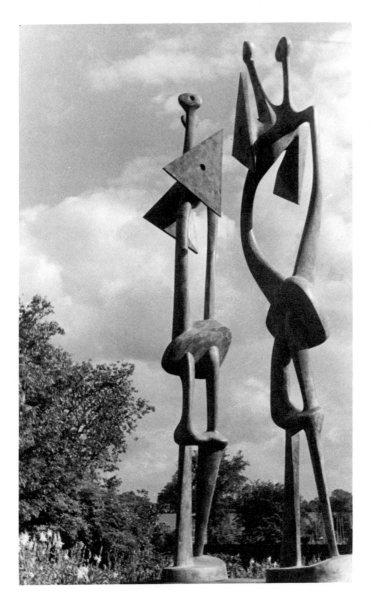

75. DOUBLE STANDING FIGURE
 Bronze. 1950. H. *87″*

The large angel figure in the landscape appears to be a model of one of the sketches that we described earlier as negative and spectral. In the drawing this figure appears in black and white on a gray background in a group of similar figures, and the piling up of grotesque, abstract, and uncanny qualities dangerously reinforces its deathly and phantasmal character. But, as a finished model set in a spacious landscape, the figure at once shows that affinity with nature which we have repeatedly emphasized as being peculiar to all Moore's sculptures. The large angel figure is now "earthed," and this not only mitigates the strangeness of its form, but exalts and spiritualizes it by bringing it into a new relationship with the heavens.

IX

WITH these strange figures from the year 1950, Moore's visionary sculpture comes to a temporary halt. But when we try to understand the work of the last decade, we come up against the difficulty mentioned earlier, namely, that his work is in a state of continual movement and development, as is shown by the great variety of motifs and styles at this period. It is in the nature of the creative process underlying Moore's productivity that this unfolding of motifs is completed only in the course of years and that their unity and consistency can be seen only in retrospect.

The wealth of new beginnings in the last few years may be rather confusing for observers who have not realized that these differences of style are like divergent branches of a single tree. Although these divergences will prove their unity only later, the connections linking the most recent works with the earlier ones are already apparent.

The stepping out of the interior figures from the heads and helmets led, as we saw, to the creation of strange spiritual or ghostly beings. The *Reclining Figure* from the year 1951 forms the transition stage be- 76, 77

76. RECLINING FIGURE
Bronze. 1951. L. 90"

77. ANOTHER VIEW OF 76

tween these spiritualized figures, whose plastic power does not lie in the use of large masses, and the reappearance of the feminine earth principle that runs through a number of Moore's sculptures in recent years. Here again different views of the same work reveal conceptions that are almost diametrically opposed to one another as regards form and content. The first view em-

76 phasizes, in its clear outlines and ponderous massiveness, the "closed" quality of organic form, and the great sweeping line sketches the picture of a woman who, notwithstanding a certain elegant beauty, is bound quietly and steadfastly to the earth. A rear view of the

77 same sculpture shows us something completely different. Jagged, wild, charged with sinister energy, this recumbent figure is more like the destroying goddess of

50 late 1939. But the combination of the two aspects in a single figure raises the artistic perfection of this late work far above the magnificence of its predecessor.

The dual or multiple significance of Moore's sculpture often makes it quite impossible for anyone to grasp the wholeness of a work from one photograph alone. This combination of multifarious aspects and contents

e.g., in one and the same work, which becomes apparent
30–32 only through intercourse with it, through perambulation round it as a thing in space, is one of the most important achievements of modern sculpture. The simplicity of earlier ages was manifest in the unity of impression which the work of art intended to convey.

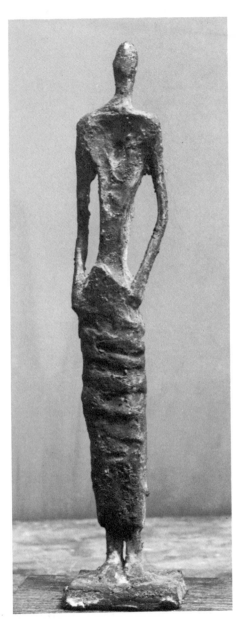

78. STANDING FIGURE NO. 3. *Bronze. 1952.* H. 8¼″

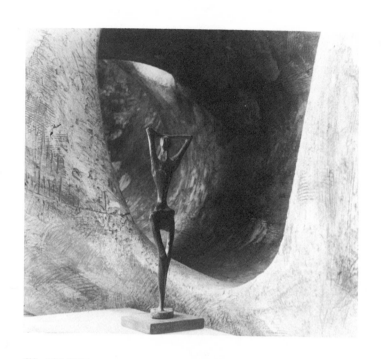

79. STANDING FIGURE NO. 1. *Bronze. 1952.* H. 9½"

The complexities and ambiguities of our age find a new and completely adequate expression in Moore's synthesis of multiple aspects of form and content in a single figure.

But this fusion of diverse trends is by no means the rule in Moore's work. As we shall see, the same polarity also expresses itself in the simultaneous execution of form groups that are almost direct opposites. Thus, in 1952, a series of sculptures begins in which a new form element comes into the foreground: the plane or lamina. It is as though the element of draftsmanship—otherwise in abeyance at this period—had reappeared

and a delicate, almost shadowy form were taking shape,
quite unlike the roundness, fullness, and cavernousness
so typical of Moore's sculptures. Indeed, these figures,

80. THIN RECLINING FIGURE.
 Bronze. 1953. L. 6″

for all their beauty, have something overrefined about
them, as if they had lost touch with nature. This can be
seen very clearly in the strange *Leaf Figures* from the
year 1952. Like the aptly termed *Thin Reclining Figure*
of 1953 and the earlier *Seated Figure,* it is not only in
their form that they exhibit a "thinness" most unusual
in Moore: the feminine in them is no longer maternal
but has dwindled to something pathetically girlish. The
connection with the earth and the earth archetype is
lacking, and the lack has not been compensated by any
genuinely powerful psychic or spiritual quality.

e.g.,
78, 79
81, 82
80
86

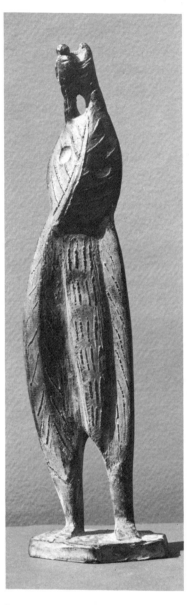

81. LEAF FIGURE NO. 1.
Bronze. 1952. H. 10″

82. LEAF FIGURE NO.
Bronze. 1952. H. 10″

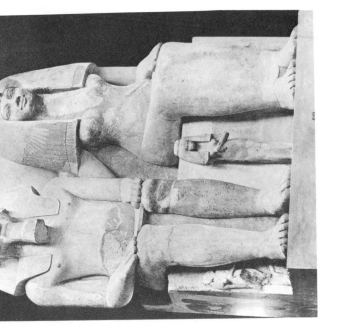

84. KING AMUN-HOTEP AND QUEEN TEYE WITH
SMALLER FIGURES OF THEIR DAUGHTERS.
Limestone. Egyptian, XVIII Dynasty. H. 23′

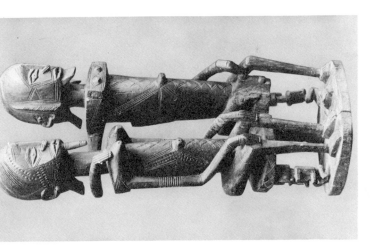

83. MALE AND FEMALE FIGURES
Dogon tribe, French Sudan.
Wood. H. C. 15″

85. TWO SEATED FIGURES (KING AND QUEEN)
Bronze. 1952/53. H. 64½″

This series culminates in the *Two Seated Figures* (*King and Queen*), from 1952/53, an important double group. It is a continuation of the earlier "family groups," but it has even stronger affinities with the series we have been discussing. This is the first and only time Moore has done a pair. Their seated posture bears a slight resemblance—if the work can be said to resemble any other work of sculpture at all—to certain pairs of mortuary figures from the rock caves of the upper Niger River, in West Africa, which are believed to embody the spirits of the family, or to the statues of the royal pair in ancient Egypt: the theme and the ceremonial attitude are the same. The fact that in England the Queen and in Egypt the King receives more emphasis is less significant than the difference of inner attitude. The Egyptian statues portray the central role of kingship: the King is the divine center of a firmly established cosmos that embraces man, nature, and the gods.[1] Moore's royal couple, on the other hand, are all too human, all too impotent, in their lonely vigilance. In Egypt the Pharaohs were divinities, but these modern royalties are oversensitive human beings. Not a glint of splendor emanates from them, no power—nothing. They sit on the edge of some event they are watching, themselves powerless. The dehumanization of the King's face, its animal resignation, is even more saddening when contrasted with the flat watchfulness of the Queen's. The Queen's wonderful hands, no less

85

83

84

90

87

88

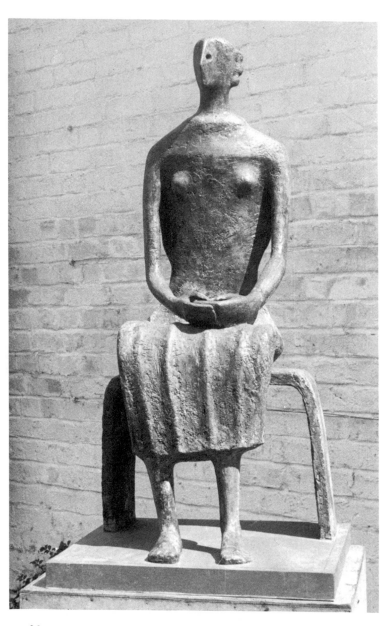

86. SEATED FIGURE. *Terra cotta. 1952/53.* H. *41″*

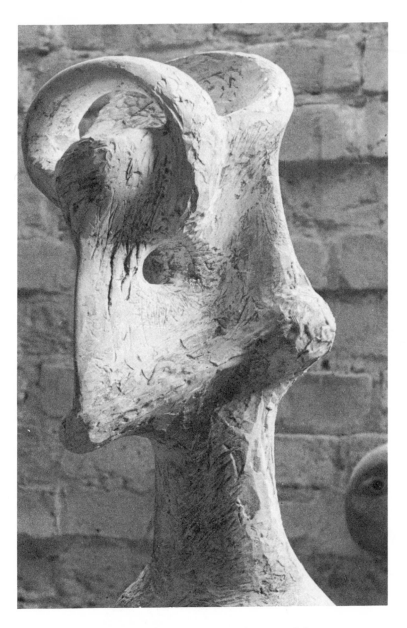

87. HEAD OF KING IN 85. *Detail of plaster model*

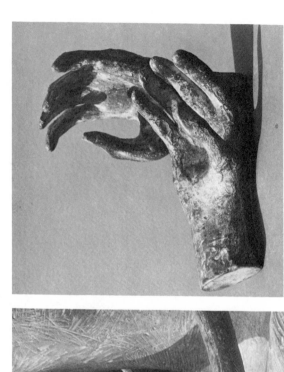

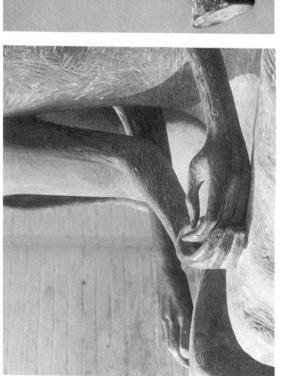

88. HANDS OF QUEEN IN 85

89. PAIR OF HANDS (STUDY FOR HANDS OF QUEEN)
Bronze. 1952. H. 5"

90. TWO SEATED FIGURES (85) IN
SITU AT SHAWHEAD, DUMFRIES

beautiful than the preliminary study on which they were modeled, express a complete, passive acceptance of fate, touching in its dignity and desolate in its loneliness. It is characteristic that, whenever the feminine loses its unconscious relationship with the earth and the mother, it becomes overrefined and almost incapable of life.

Already in this pair we sense a peculiar barrenness, a loosening of the tie with the creative depths, which is even more evident in the archetypal *Mother and* *Child* from 1953. This is perhaps the most negative expression of the mother-and-child idea in the whole of Moore's work. The birdlike child snapping at the breast is a motif whose significance lies in the fact that the gaping beak never gets what it wants. This beak, in conjunction with the clutching arm that symbolizes the mother-child relationship, is a negative modulation of the old motif. What was formerly the symbol of *participation mystique* has now become the very thing that holds the child off and grips it fast. It is the cruel Tantalus situation, where the greedy infant has the longed-for object perpetually before its eyes without ever being able to reach it. The spiky head of the woman reinforces the negativism of her attitude. It is a picture of the Terrible Mother, of the primal relationship fixed forever in its negative aspect. Once again the artist's intuition has given shape to an archetypal situation: the eternal and insatiable longing of those who are bound

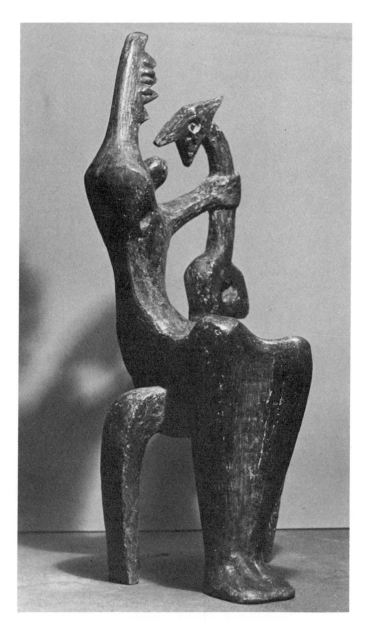

91. MOTHER AND CHILD. *Bronze. 1953.* H. *20"*

92. HEAD OF PROMETHEUS
Chalk, water color, and pencil. 1951. 13¾ × 10½″

to a negative mother. Just as in the positive relationship
20 the child is shown firmly rooted in the mother and in
the world, so in the negative relationship it is shown
thrust away from the mother and suspended almost
rootlessly in the air.

Whereas the feminine, in good and evil alike, exer-
cises a fatelike power in Moore's work, the masculine al-
ways remains stuck at the "adolescent" stage and never

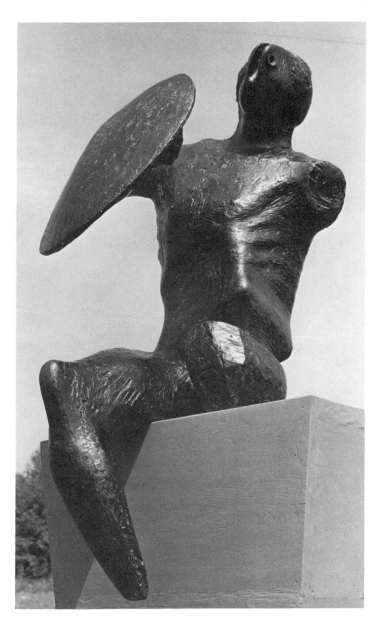

93. WARRIOR WITH SHIELD. *Bronze. 1953/54.* H. 60"

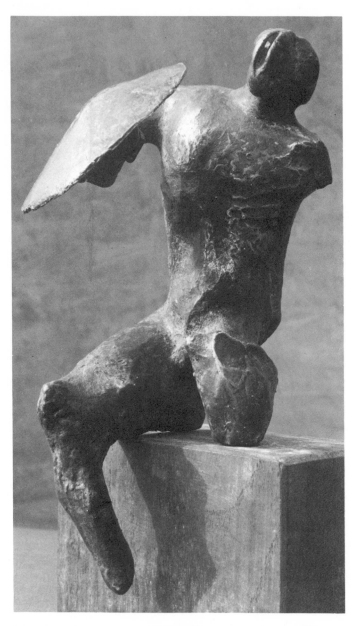

94. MAQUETTE FOR WARRIOR. *Bronze. 1952/53.* H. 7¾″

95. DETAIL OF 93

gets beyond the phase of bondage to the Great Mother. We are thinking here not only of the overdelicate figure of the King but of the youthful *Head of Prometheus*, 92 whom no one would credit either with having made humanity or with the theft of fire. This "negative" male group is completed by Moore's figure of the *Warrior with Shield*, perhaps the strangest and most gruesomely 93 tragic warrior that ever an artist created. The left arm, the right foot, and half the left leg are missing; he is the very symbol of mutilation. With his sound right arm he holds not a sword but—in hopeless and despairing de-

fense—a shield. Defense is the only thing left him, the Struggler,[2] vainly trying to fight off the negative powers. The head, which looks split, the cut mouth, present a picture of fear and defenselessness that is seen at its clearest when he is robbed even of his shield. This warrior is the most devastating portrayal in all art of a suprapersonal castration complex; it shows complete capitulation before the forces of destruction.[3]

It would be entirely wrong to assume, however, that this series of negative, "earthless" creations is in any way connected with a negative personal constellation in Moore. Quite the contrary. For already in 1951, simultaneously with the reclining figure whose double aspects we discussed above, and the "thin" sculptures, there grew up a powerful counter-series in which quite different elements of form and content occupy the foreground.

Although the *Animal Head* from 1951 is a bronze, it looks like a stone, a natural object. As in mythology men were made out of stones, and the stone in alchemy symbolizes the life-containing secret, so here the stone has given birth to something organic, an animal's skull. It is not just a copy of a particular animal species but seems rather to be the primordial image of a whole group of them. We know that there are stones lying about Moore's studio, which he has picked up on his walks and whose richness of form he follows in the development of his work. In the naturalness of his sculp-

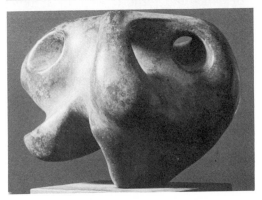

96a–c. **ANIMAL HEAD.** *Bronze. 1951.*
L. 12″ H. 8½″

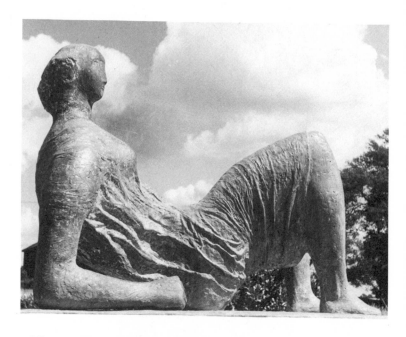

97. DRAPED RECLINING FIGURE
Bronze. 1952/53. L. 62"

ture are expressed not only the naturalness of the stone
but the beauty of its natural form, its emotional alive-
ness, and the workings of chance, rubbing, polishing,
splitting, sharpening, or wearing down the outlines.
All this is for Moore an endlessly resourceful teacher,
whose suggestions he follows half unconsciously, half
rationally, with that peculiar mixture of creative pas-
sion and intellectual clarity that distinguishes him as
an artist. This animal skull shows particularly clearly
the formative and transformative power of an artist
whose creative energy enables him to call forth a whole
world of animal life from a piece of stone.

98. DETAIL OF 97

The mastery which enables Moore to create, side by side and in accordance with the task he is set, forms that are mutually opposed to one another is to be seen most clearly of all, perhaps, in the two works he executed for the Time-Life Building in London. The first work is a near-naturalistic reclining figure of a woman, 97–100 the other, adapted to the architecture of the building, is a "screen," the balustrade for a terrace, which Moore 2, 3 designed as a series of abstract sculptures.

The profile views of the *Draped Reclining Figure* from 1952/53 show a deployment of mass that is unique

97, 99 in Moore's work. The draping, a variation of the blanket motif, gives the whole figure an ease of line that expresses her earthbound tranquillity in an almost classical way. But the novel and surprising thing about this figure is its girlishness. It is not an Earth Mother who lies here before us, but a young woman, delicately shaped for all the emphasis on spatial units.

Moore has some interesting notes on the drapery, a form principle used here for the first time after his travels in Greece.[4] The most important in the present context is the following remark: "Also in my mind was to connect the contrast of the sizes of the folds, here small, fine and delicate, in other places big and heavy, with the form of mountains, which are the crinkled skin of the earth. (This analogy, I think, comes out in the 98 close-up photographs taken of the drapery alone.)"

When we compare this figure with the one most Frontis., 101 closely resembling her, the *Memorial Figure* from 1945/46, we are struck at once by the different manner of simplification, which in both cases is achieved by the same technical means: the drapery. The tranquillity 101 of the top half of the *Memorial Figure,* further emphasized by the resting arm and the curve of the robe slipping off the breast, is dramatically offset by the position of the legs, which produces the effect of a deep chasm, and by the sweeping longitudinal fold of the robe joining the left arm to the right thigh.

In the profile of the 1952/53 *Draped Reclining Fig-*

99. ANOTHER VIEW OF 97

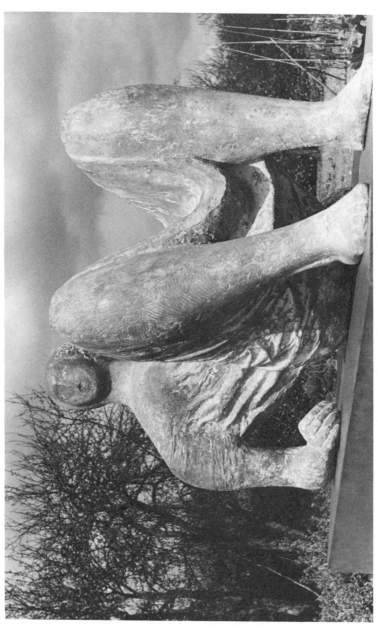

ure, however, everything dramatic has disappeared. 99
All the lines have been simplified to the utmost, and the effect of this simplification is to strengthen, perhaps even to evoke, the "girlish" character of the figure.

The impression changes in a flash when we see the other view of the same figure. Here is a formidable 100 earth woman whose massive bulk is full of compressed energy. Despite the looseness of the body and its easy repose, the sturdy legs, flexed up and lightly splayed, with the heavy loop of skirt hanging between them, suggest a mature woman, fecund, maternal, earthy—a fine breeder with nothing in the least girlish about her. That two visual aspects of the same figure should be able to express the unity of mother and daughter, which is one of the central problems of feminine psychology,[5] makes this work a masterpiece of modern sculpture.

It was just at this time that Moore did the *Time-Life* screen, flanking one side of a large terrace, its forms co- 2, 3 ordinated with the abstract design of the building. The monumental power of these abstract figures—in the bronze model they could be made to turn round a central axis—is even more striking when one sees them in their full size, outside the niches into which they are now fitted. Although designed as pure forms, they have the effect of archaic gods. Their affinity with the figures of the earlier abstract period is obvious, but this closely- 18, 20, 26 knit quaternity of images is much more impressive and numinous in its bizarre beauty. For whereas the earlier

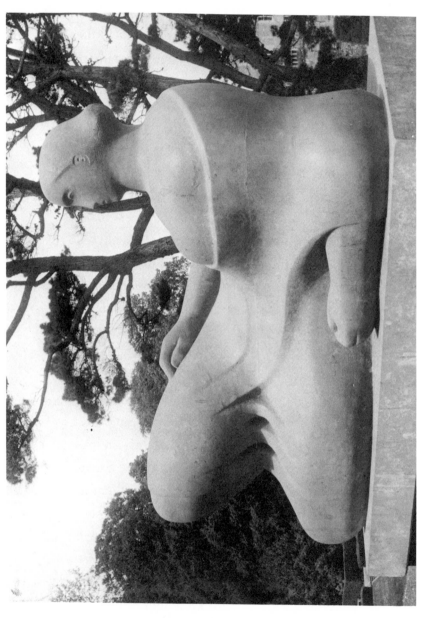

101. MEMORIAL FIGURE. *Hornton stone. 1945/46. L. 56″*

figures belonged to nature, these are set in the land-
scape of a metropolis, stone of its stone, severe and ab-
stract as the city itself; and yet they have the enigmatic
sublimity of those nature gods who are sexless and bi-
sexual at once, daemonic and divine.

Once more we must go back to the year 1951, a veri-
table seedbed of forms, in order to follow the most re-
cent series of sculptures, where Moore addresses him-
self to the oldest formal problems of his work and
arrives at a completely new synthesis. This series of "In-
ternal and External Forms" begins with the *Working
Model for a Reclining Figure*. The breakdown of mass 102
in his sculptures had already begun with the "open-
ing out" of the female figure; the surface as a closed,
terminal structure, the skin as the boundary of the per-
sonality, had ceased to exist. This led, as we have tried
to show, to the formation of an interior body space.
With the return to "haptic" experience, inside and out-
side became interchangeable, so that a breast could be
represented either as a round vessel or as a cuplike
opening leading into the body cavity.

The mother-child relationship, which, as the primary
relationship between the containing mother and the
contained child, determines the life of man and charac-
terizes his existence in the world, expresses itself over
and over again in Moore's work as a *participation
mystique*. On the deeper archetypal level, this re-
lationship forms the background of the mythological re-

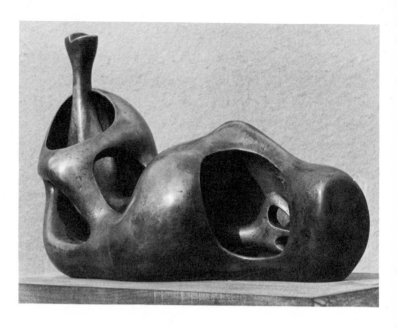

102. WORKING MODEL FOR A RECLINING FIGURE
Bronze. 1951. L. 21"

lationship of soul to body, where the soul appears as the body's inhabitant. During the second World War the feminine archetype of the earth as the protective "container" asserted itself very clearly in Moore's shelter drawings, and the time was now ripe for a plastic representation of this mythology of body and soul, outside and inside. The next step toward the solution of this problem—whose content has probably remained completely unconscious to Moore, though its formal aspect has occupied him unceasingly—resulted in the heads and helmets of 1940 and 1950, where the head becomes

the maternal vessel containing the interior soul child.

In Moore's latest work, the problem of the mother-child relationship is no longer restricted to the head as the containing vessel: the body of the maternal container appears once more in its entirety and becomes the dominant theme of the 1951 *Working Model for Internal and External Forms*. The same principle of con- *103* tainer and contained, mother and child, body and soul, which underlay the helmets reappears on a large scale in the *Internal and External Forms* (1952/53), the later *104* large form (1953/54) being the "authentic" representa- *105* tion of which the earlier miniature in bronze is only a *103* sketch.

What we see here is the mother bearing the still unborn child within her and holding the born child again in her embrace. But this child is the dweller within the body, the psyche itself, for which the body, like the world, is merely the circumambient space that shelters or casts out. It is no accident that this figure reminds us of those Egyptian sarcophagi in the form of mummies, showing the mother goddess as the sheltering womb that holds and contains the dead man like a child again, as at the beginning. Mother of life, mother of death, and all-embracing body-self,[6] the archetypal mother of man's germinal ego consciousness—this truly great sculpture of Moore's is all these in one. And just for that reason it is a genuine bodying forth of the unitary reality that exists before and beyond the division into inside

105. INTERNAL AND EXTERNAL FORMS. *Elmwood.*
1953/54. H. 103¼″.

103. WORKING MODEL FOR INTERNAL AND
EXTERNAL FORMS. *Bronze.* 1951. H. 24½″.

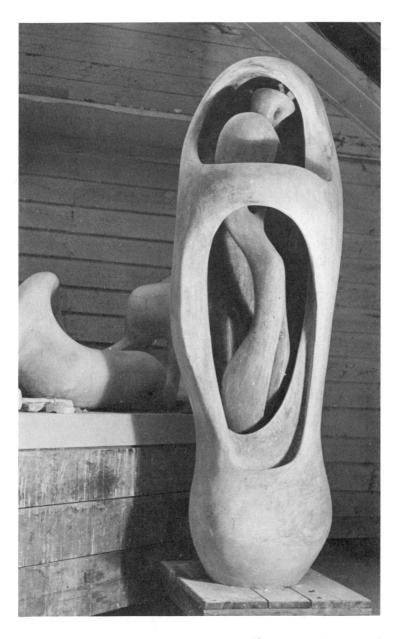

104. INTERNAL AND EXTERNAL FORMS. *Plaster*. 1952/53. H. 79"

and outside, a profound and final realization of the title it bears: *Internal and External Forms*. Outside and inside, mother and child, body and soul, world and man —all have been made "real" in a shape at once tangible and highly symbolic.

In the *Reclining Figure* (*Internal and External Forms*) from 1953/54, the container, as pure space, has been almost wholly resolved into an organic abstraction. Its connection with the human figure is still recognizable, but the principle of the de-individualized hollow form has been carried further here than anywhere else in Moore's work. Woman has become the vessel absolute, the place of entrance and exit, a pure earth form made of cavities and hollows.

The emergence of an archetype, i.e., a collective unconscious content active in the psyche of large numbers of people, makes itself felt in many fields. Its coming to consciousness finds expression in psychic disturbances as well as in the creative processes of art, in sociological changes as well as in the revaluations of philosophy. One of the central problems of our age is the activation of the earth archetype,[7] and more particularly of the feminine archetype in general.[8] This archetype compensates the crisis of our one-sided patriarchal culture, for it symbolizes the essence of human relatedness, whose source lies in the primary relationship to the mother. Through his ceaseless formation and transformation of

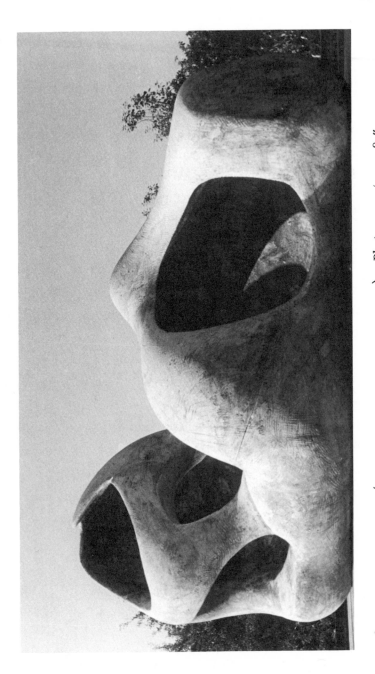

106. RECLINING FIGURE (INTERNAL AND EXTERNAL FORMS). *Plaster. 1953/54. L. 84"*

this central content, Moore has not only created a corpus of great works of art but is helping a new age into being. The birth of the feminine archetype in modern man signifies at the same time the development of human relatedness, of his social capacity, and the growing consciousness of the unity of mankind on earth. This feeling of human solidarity rests on the archetypal connection with the Great Mother from whom all life springs, the primary relationship which Moore has depicted over and over again.

His other leading idea, the reclining figure, is the Feminine in and for itself, unrelated to anything human. The representation of this archetype goes beyond the limitations of the earth archetype, which is only *one* side of the Feminine. In penetrating to the all-embracing nature of the unitary reality, where outside and inside are transcended, Moore has broken through to a new layer of psychic contents and to a new form of sculpture. The motto for this stage of artistic experience might well be Goethe's lines, which apply just as forcefully to every creative development of modern man:

> *And so I say to you once more:*
> *Nature has neither skin nor core!*
> *Then test yourself and tell me true:*
> *Which one of these, O man, are you?* [9]

NOTES

I

[1] Cf. my "Art and Time."

[2] Cf. my *Tiefenpsychologie und neue Ethik*.

[3] Cf. my "Die Bedeutung des Erdarchetyps für die Neuzeit."

[4] Cf. Henri Frankfort, *Ancient Egyptian Religion*.

II

[1] Quoted by Herbert Read in his introduction to *Henry Moore: Sculpture and Drawings*, Vol. I (4th edn., 1957), p. xxv. [This vol. and the one succeeding, *Sculpture and Drawings since 1948* (1955), are hereafter referred to as *Moore*, I and II. The quotations of Henry Moore himself are from Vol. I unless otherwise indicated.—Ed.]

[2] Herbert Read commented on this relationship in his *The Art of Sculpture*, pp. 119-20.

[3] "Primitive Art," p. xxxvii.

[4] Sylvester, *Catalogue*, p. 10. [This designates a publication entitled *Sculpture and Drawings by Henry Moore*, which was issued for an exhibition organized by the Arts Council and held at the Tate Gallery in 1951.—Ed.]

[5] "A View of Sculpture," p. xxx.

[6] For the "maternal" significance of the head, see below, pp. 98-100.

[7] Moore, "Notes on Sculpture," pp. xxxiii f.

[8] Cf. my "Der Mond und das matriarchale Bewusstsein."

[9] *Mother and Child*, Styrian jade, H. 4 in., Coll. Mrs. Philip Trotter, London (*Moore*, I, no. 51, p. 33; previous edns., pl. 10a, b).

[10] "The Sculptor's Aims," p. xxxi.

[11] "Notes on Sculpture," p. xxxv.

III

[1] "Notes on Sculpture," p. xxxv.

[2] In Sylvester, *Catalogue*, p. 4.

[3] "Notes on Sculpture," p. xxxv.

[4] "Primitive Art," p. xxxvi.

[5] Ibid.

[6] Sylvester, *Catalogue*, p. 12.

[7] Ibid., p. 13.

[8] "Primitive Art," p. xxxvii.

[9] Ibid.

[10] Cf. my "Zur psychologischen Bedeutung des Ritus."

[11] We cannot discuss here the stringed figures from the year 1939: *Moore*, I, nos. 200-201 (earlier edns., pls. 93a, b).

IV

[1] See below, pp. 98-106.

[2] "Notes on Sculpture," p. xxiv.

[3] Sylvester, *Catalogue*, p. 14.

[4] Cf. my "Leonardo da Vinci and the Mother Archetype"; also "Die Bedeutung des Erdarchetyps für die Neuzeit."

[5] Cf. my "Creative Man and Transformation."

[6] Cf. my "Art and Time."

[7] The parallel would be, say, a medieval painter who painted not only Madonnas but witches, hetaerae, classical goddesses, etc. But this was made almost impossible for him by his adherence to the cultural canon of his time.

[8] Sylvester, *Catalogue*, p. 14.

[9] "Notes on Sculpture," p. xxxv.

[10] Cf. my "Die Erfahrung der Einheitswirklichkeit und die Sympathie der Dinge."

[11] Cf. my "Zur psychologischen Bedeutung des Ritus" and *The Great Mother*, Part I.

[12] Cf. Jung, *Symbols of Transformation*, Part II, and my *Origins and History of Consciousness*.

[13] Jung, "Psychic Conflicts in a Child," in *The Development of Personality*, pp. 4 f.

[14] As in the following poem from the Irish of Douglas Hyde (trans. Lady Gregory; *Oxford Book of Modern Verse*, p. 35):

> I am in the little road
> That is dark and narrow,
> The little road that has led
> Thousands to sleep.

V

[1] Ch. XVIII: "The Perils of the Soul."
[2] Cf. the dream reported in "Zur psychologischen Bedeutung des Ritus."
[3] Gert Schiff, "Die Plastik, der Mensch und die Natur. Eindrücke von einem Besuch bei Henry Moore."
[4] J. J. Sweeney, *Henry Moore*.
[5] *Moore*, I (1st–3rd edns. only), pl. 171a.
[6] See my "Leonardo da Vinci."

VI

[1] Sylvester, *Catalogue*, p. 16.
[2] Cf. *The Great Mother*, pp. 104–12.
[3] *Gedichte in zeitlicher Folge*, II, p. 224.
[4] Sweeney, *Henry Moore*, p. 73.
[5] Cf. also Soby, *The Early Chirico*, pls. 6–8, 14, 15.
[6] Whether this phenomenon actually occurred earlier cannot be decided for certain, since we have to rely on the published reproductions.

VII

[1] *Psychological Types*, index, s.v. "reconciling symbol."
[2] "The Sculptor's Aims," p. xxxi.
[3] In Read's introduction, *Moore*, I, p. xxv.
[4] One of the maquettes for the *Madonna* (fig. 57), where the child sits "in" the mother, as if on a high-backed throne, is like an activation of the archetypal image of the great Mother Goddess of Egypt, whose name Isis actually meant "throne." Cf. my *Great Mother*, pp. 98–100.
[5] "Notes on Sculpture," p. xxxiv.
[6] "Primitive Art," p. xxxvii.

VIII

[1] Cf. two terra-cotta maquettes, 1945: pls. 70m, o, in *Moore*, I, 3rd edn. (Former only = no. 244, p. 15, 4th edn.)
[2] Cf. *Katha Upanishad*, IV, 1: "The Self-created pierced the windows of the body outward, man therefore looks outward, not into himself."
[3] Sculptures: Cf. our pl. 50, and *Moore*, I, 3rd edn., pls. 101a, 102a, 103a, 106b (= 4th edn., nos. 192, 202, 204, and 259).

Drawings: Our pls. 43 and 61, and *Moore*, I, 3rd edn., pls. 151b, 162a, 165a, 223 (= 4th edn., pp. 216 top and 225 bottom, others lacking).

[4] [The Indian *purusha* originally meant "man"; later it became spiritualized. Cf. *Maitri Upanishad*, VII, 11, 1: "This Person (purusha) in the right eye"; also Georg Misch, *The Dawn of Philosophy*, pp. 137 f.—Tr.]
[5] "Die Bedeutung des Erdarchetyps für die Neuzeit."

IX

[1] Frankfort, *Ancient Egyptian Religion*.
[2] Cf. my *Origins and History*, index, s.v. "Strugglers."
[3] The *Warrior* leads via the feminine and hollowed-out *Draped Torso* (*Moore*, II, pl. 63) to the *Seated Figure* of 1954 (II, pl. 52).
[4] "Notes on the Draped Reclining Figure," in *Moore*, II, p. xvi.
[5] Cf. my "Die psychologischen Stadien der weiblichen Entwicklung."
[6] Cf. my *Origins and History*, pp. 288 ff.
[7] Cf. my "Die Bedeutung des Erdarchetyps für die Neuzeit."
[8] Cf. *The Great Mother*.
[9] "Ultimatum," in *Gedichte in zeitlicher Folge*, II, p. 261.

FRANKFORT, HENRI. *Ancient Egyptian Religion*. New York, 1948.

FRAZER, JAMES GEORGE. *The Golden Bough*. Abridged edn., New York, 1951.

GOETHE, J. W. VON. *Gedichte in zeitlicher Folge*. Leipzig (Insel Ausgabe), n. d. 2 vols.

JUNG, C. G. *The Development of Personality*. Translated by R. F. C. Hull. (Collected Works, 17.) New York (Bollingen Series XX) and London, 1954.

——. *Psychological Types*. Translated by H. G. Baynes. London and New York, 1923. (To be pub. in the Collected Works as Vol. 6.)

——. *Symbols of Transformation*. [4th rev. edn. of *Wandlungen und Symbole der Libido*, orig. tr. as *Psychology of the Unconscious*.] Translated by R. F. C. Hull. (Collected Works, 5.) New York (Bollingen Series XX) and London, 1956.

MISCH, GEORG. *The Dawn of Philosophy*. Edited and translated by R. F. C. Hull. London, 1950; Cambridge, Mass., 1951.

[MOORE, HENRY.] *Henry Moore: Sculpture and Drawings*. With an introduction by Herbert Read. 3rd edn., London, 1949. 4th edn. (designated *Volume One, 1921–1948*, and edited by David Sylvester), London, 1957.

——. *Henry Moore: Volume Two, Sculpture and Drawings since 1948*. With an introduction by Herbert Read. London, 1955.

NEUMANN, ERICH. *Art and the Creative Unconscious*. Translated by Ralph Manheim. In press.

——. "Art and Time." In *Art and the Creative Unconscious*, q.v. Also in: *Man and Time*. (Papers from the Eranos Yearbooks, 3.) New York (Bollingen Series XXX) and London, 1958.

NEUMANN, ERICH, continued. "Die Bedeutung des Erdarchetyps für die Neuzeit." *Eranos-Jahrbuch 1953* (Zurich, 1954).

————. "Creative Man and Transformation." In *Art and the Creative Unconscious,* q.v.

————. "Die Erfahrung der Einheitswirklichkeit und die Sympathie der Dinge." *Eranos-Jahrbuch 1955* (Zurich, 1956).

————. *The Great Mother.* Translated by Ralph Manheim. New York (Bollingen Series XLVII) and London, 1955.

————. "Leonardo da Vinci and the Mother Archetype." In *Art and the Creative Unconscious,* q.v.

————. "Der Mond und das matriarchale Bewusstsein." In *Zur Psychologie des Weiblichen,* q.v.

————. *The Origins and History of Consciousness.* Translated by R. F. C. Hull. New York (Bollingen Series XLII) and London, 1954.

————. *Zur Psychologie des Weiblichen.* (Umkreisung der Mitte, 2.) Zurich, 1953.

————. "Zur psychologischen Bedeutung des Ritus." *Eranos-Jahrbuch 1950* (Zurich, 1951). Also in: ERICH NEUMANN. *Kulturentwicklung und Religion.* (Umkreisung der Mitte, 1.) Zurich, 1953.

————. "Die psychologischen Stadien der weiblichen Entwicklung." In *Zur Psychologie des Weiblichen,* q.v.

————. *Tiefenpsychologie und neue Ethik.* Zurich, 1949.

The Oxford Book of Modern Verse, 1892–1935. Edited by W. B. Yeats. Oxford, 1936.

READ, HERBERT. *The Art of Sculpture.* (The A. W. Mellon Lectures in the Fine Arts, 1954.) New York (Bollingen Series XXXV, 3) and London, 1956.

SCHIFF, GERT. "Die Plastik, der Mensch und die Natur. Eindrücke von einem Besuch bei Henry Moore." *Tagesanzeiger für Stadt und Kanton Zürich,* Jan. 6, 1954.

SOBY, JAMES THRALL. *The Early Chirico.* New York, 1941.

SWEENEY, JAMES JOHNSON. *Henry Moore.* New York (Museum of Modern Art), 1947.

[SYLVESTER, A. D. B.] *Sculpture and Drawings by Henry Moore.* Catalogue of an exhibition . . . held [at the Tate Gallery] on the occasion of the Festival of Britain. With a foreword by Philip James. London (Arts Council), 1951.